DEFINING FEATURES

DEFINING FEATURES

Scientific and Medical Portraits
1660–2000

LUDMILLA JORDANOVA

PUBLISHED IN ASSOCIATION WITH
THE NATIONAL PORTRAIT GALLERY, LONDON,
BY REAKTION BOOKS

For A, with love

Blest be the art that can immortalize,
The art that baffles Time's tyrannic claim
To quench it . . .

WILLIAM COWPER,
'On the Receipt of my Mother's Picture Out of Norfolk'

This book was published to accompany an exhibition at
the National Portrait Gallery, London.

Published by Reaktion Books Ltd in association with
the National Portrait Gallery, London

Reaktion Books Ltd
79 Farringdon Road, London ECIM 3JU, UK
www.reaktionbooks.co.uk

First published 2000

Designed by Philip Lewis
Printed and bound by in Italy by Conti Tipocolor srl

BRITISH LIBRARY CATALOGUING IN PUBLICATION DATA
Jordanova, L. J. (Ludmilla J.)
Defining features: scientific and medical portraits, 1660–2000
1. Scientists – Portraits 2. Physicians – Portraits
3. Technologists – Portraits 4. Science in art 5. Medicine in art
6. Technology in art
I. Title
704.9'4950922

ISBN 1 86189 059 1

CONTENTS

FOREWORD

One of the conventions of the National Portrait Gallery is that it maintains a room on the ground floor dedicated to portraits of scientists. Within this room, the portraits maintain subtly different conventions of depiction from those of the artists, writers and composers on the other side of the corridor. Dorothy Hodgkin, for example, is instantly identifiable as a scientist, and not merely because of the diagrams covering the paper on which she is writing and the molecular model that identifies the realm of her discoveries. It is implausible to think of a writer who might be depicted in her official portrait as too busy to look up at the artist, too immersed in the world of discovery to be bothered with the niceties of posing for her portrait. Thus does Maggi Hambling draw on a long tradition whereby the scientist has a significant place in the world, but is in some sense withdrawn from it.

It is a great virtue of the book that Ludmilla Jordanova has written to accompany her exhibition *Defining Features: Scientific and Medical Portraits 1660–2000* that it encourages the reader to think about the conventions of such portraits across a broad historical period. The book ranges from the time of the foundation of the Royal Society, when the definition of what constituted 'science' was fluid and a writer and connoisseur such as John Evelyn was able to be a Fellow, through the early eighteenth century, when Sir Isaac Newton was regarded as a national hero in spite of the heterodoxy of his religious beliefs, to the nineteenth century when professional boundaries were much more carefully drawn. Both book and exhibition come right up to our time, whether examining institutional portraits of today's scientists or popular representations of the scientific heroes of the past. The conventions determining how scientists wished themselves to be depicted were never static, but instead followed changes in the status of science itself.

For the last two years, owing to building works, the National Portrait Gallery has been unable to hold the type of small, analytical exhibitions in its downstairs Studio Gallery of which this should be an excellent example.

So, we were very pleased when approached by Professor Jordanova with a suggestion that we might hold an exhibition on portraits of scientists to coincide with a special conference of the British Society for the History of Science, of which she is President. We felt that this would be the perfect show with which to re-open the Studio Gallery and expect it to demonstrate our commitment to academically innovative and thought-provoking exhibitions which help to bring new approaches to the study of portraiture to a wider public.

We are all especially grateful to Professor Jordanova for the amount of care, energy and enthusiasm she has put into the project, particularly since she has so many other academic and professional commitments; to the many institutions and their staffs who have generously loaned works to the exhibition; and to Reaktion Books for taking this publication on, thereby demonstrating their long-standing support for innovative scholarship.

Charles Saumarez Smith
Director
National Portrait Gallery

PREFACE AND ACKNOWLEDGEMENTS

Defining Features came about because of an exhibition at the National Portrait Gallery, London, between April and September 2000. Accordingly, I owe a major debt to the staff of that institution for their interest, enthusiasm, patience and constructive help over the past year. I thank especially Christine Byron, John Cooper, Susie Foster, Peter Funnell, Beatrice Hosegood, Charles Saumarez Smith and Kathleen Soriano. Without the encouragement of my colleague Nichola Johnson I would not have proposed the exhibition to the NPG in the first place, and, having enjoyed the experience hugely and learnt a great deal from it, I offer her my warmest thanks.

In writing the book, I have visited and contacted many institutions and received much kindness from those who work in them. My gratitude goes to the Jenner Museum, Berkeley, Gloucestershire; the Plymouth Medical Society; the Royal College of Surgeons, London; the Royal College of Physicians, London; the Royal Institution, London; the Royal Society, London; the Science Museum, London; Somerville College, Oxford; and the Wellcome Institute, London.

My thinking about portraiture has been shaped by undergraduate and postgraduate teaching I have undertaken at the Universities of York and East Anglia, and by innumerable conversations with Malcolm Baker and Marcia Pointon, dear friends who have been a constant source of help and encouragement. The members of the eighteenth-century visual culture research group at the University of East Anglia provided a stimulating and congenial environment in which to discuss my ideas.

On a more practical level, for their help in preparing this volume I would like to thank Sue Baksa, Janet Browne, Enrico Coen, David Cole, Jacky Colliss Harvey, Peter Goddard, Clare Haynes, Hester Higton, Frank James, Chris Lawrence, Andy Nolan, Martin Rudwick, William Schupbach, Jeremy Taylor, Lesley Yellowlees and members of the Science Museum seminar. I would like to acknowledge the useful comments I received from Michael Leaman at Reaktion Books and an anonymous reader. I am

particularly appreciative of the care Peter Funnell took in reading and responding so constructively to drafts.

Over the time I have been writing this book, its dedicatee has been a great source of support and purveyor of fun, which I appreciate more than it is possible to say.

Ludmilla Jordanova
Norwich
October 1999

I

INTRODUCING PORTRAITURE

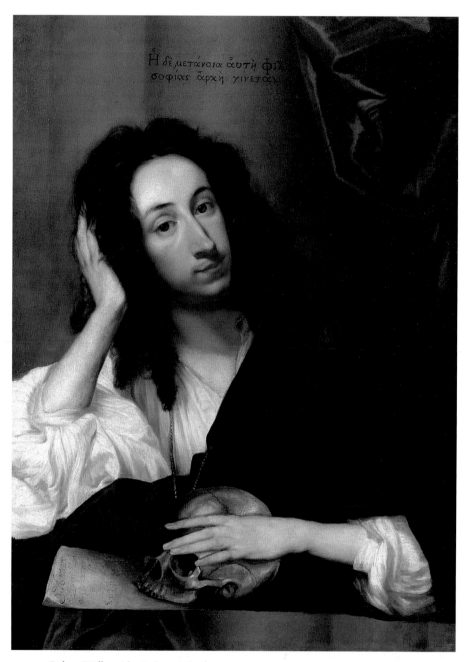

1 Robert Walker, *John Evelyn*, 1648, oil on canvas, 87.9 × 64.1 cm.
 Although best known as a diarist, Evelyn was an important member of the Royal
Society who concerned himself with social improvement. In politics, he was a Royalist.

Defining Features is concerned with portraits of a specific yet ill-defined group of people over four centuries. We could refer to the members of this grouping as 'scientists', although the term is in fact misleading. In 1660, the year in which the Royal Society of London, one of the world's premier scientific institutions, was founded, the word *scientist* did not exist. The membership of the Royal Society in its early years appears strikingly heterogeneous – antiquarians, medical practitioners, natural philosophers, writers, natural historians and other learned men (illus. 1). *Scientist* is a nineteenth-century invention, coming into use at a time when laboratory research was a minority activity among those who studied the natural world. The portraiture of individuals who can be grouped together as 'scientists' – doctors, engineers, geologists and so on – is a huge subject. Over the last 340 years, many representations of such people have been produced in a wide range of media. The subjects of these portraits were defined in terms of what they did, and so to a degree this volume is a study of how a related set of occupations was depicted. It is also a study of portraiture itself.[1]

It is unproductive to examine the people who appear in portraits without first considering the kinds of activity involved in making a representation of a person. Portraiture is always art.[2] We can think about the term *art* in two ways. First, there is the obvious and familiar meaning – high levels of skill combined with visual interest and pleasure. In this sense, many portraits are exquisite, complex and challenging as art. Second, there is the older meaning of art, something made by human actions. Human actions always take place in specific social contexts. When looking at a portrait, viewers generally ask first about the sitter, unless the artist is exceptionally

highly rated. They rarely consider the encounter between artist and sitter, the social contexts in which portraits are produced. Sometimes, it is hard to find direct evidence of these encounters, which need nonetheless to be taken into account, if only in general terms and using circumstantial evidence, in order to conceptualize a portrait as one stage of a social process. In this chapter, I shall therefore consider some of the basic issues portraiture raises, bearing in mind that my main concern is with the representation of those who study nature, including human nature. We can call what they produce natural knowledge.

So, what is a portrait? There are no simple answers to this question, but posing it is essential. For me there has to be a recognized or potentially recognizable person involved, whether they sat for an artist or were depicted from memory or from an existing representation, possibly after death. In other words, portraits evoke particular people by visual means. Societies have many ways of doing this, of which recognizable depictions of the body are only one. Relics and mementos, for example, evoke specific persons visually, but not mimetically. Hence, portraits depend on an idea of 'likeness'. But the idea of likeness is not as straightforward as it sounds. Portraits follow conventions, as do all cultural products. These are tacit rules which make sense at a particular time and place, and which people imbibe unawares as they are growing up. It is the job of scholars to work out what the conventions are, how they function and the means by which they change. Notions of likeness are not so specific that viewers are unable to make sense of portraits produced hundreds of years ago, but they can easily make mistakes or simply be unaware of meanings that would have been obvious to contemporaries. Changing conventions are particularly evident in the accoutrements depicted in a portrait to provide information about the sitter. Contemporary viewers, however, are likely to respond most immediately to the face in a portrait and to ask whether it is a 'good' likeness.

Likeness is also a complicated idea partly because there is generally little independent evidence of what people in the past looked

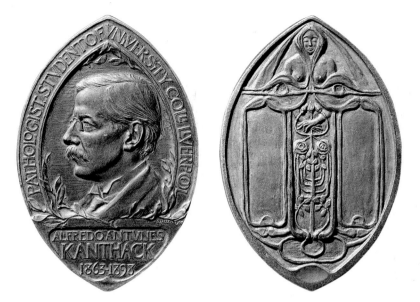

2 C. J. Allen and J. H. McNair, Obverse and reverse of medal showing Alfredo Antunes Kanthack, 1900, bronze, 9.5 × 6.4 cm (pointed oval).

This unconventional medal must have appeared extremely daring when it was produced. Born in Brazil, Kanthack studied in Germany and enjoyed a successful medical career. He died young shortly after becoming Professor of Pathology at the University of Cambridge.

like. For a few people we have a number of portraits, sometimes a very large number indeed, and, although it is possible to discern similarities between them, it can be equally noticeable how different they are. Even where direct knowledge of a person is possible, the matter remains complex. Take three pictures of a given individual, and they will see themselves more readily in one than in the others. Show the same three pictures to people who know the individual in question, and they will have divergent reactions about which is the 'best' likeness. 'Likeness', then, is highly subjective. In everyday life, we use the phrase 'It's just not you/me', which in one sense is a quite meaningless statement. But it reveals the profound truth that some representations are taken to capture a person more effectively than others, even if there is no consensus as to which ones they are. So, there's no resting point, no objective evidence we can turn to in

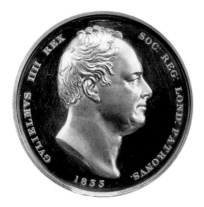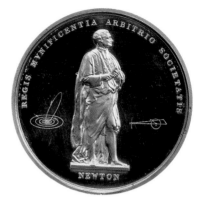

3 William Wyon, The Royal Society of London's Royal Medal (Gold), dated 1833, d: 7 cm.
 This medal, which depicts the reigning monarch on one side and Sir Isaac Newton on the other, was presented to Michael Faraday in 1835. Along with his other medals, it was sold to the British Museum in 1868 by his widow. Faraday, who won the same medal a second time in 1846, was a man of strong religious belief whose best-known work was on electricity and magnetism.

determining whether something is a 'good' likeness. But it is possible to observe that some artistic conventions elicit more trust in their capacity to depict a person accurately than do others. Other types of portraits, such as those on coins and medals, have an especially strong formulaic element, making detailed likeness less important (illus. 2, 3). In these respects, portraits are unlike everyday life in that they provide only a limited number of visual cues, whereas when looking at actual people we quite unthinkingly use a huge range of features to identify and respond to them. Portraits invite us to pay conscious attention of a very particular kind to other people.

IDENTITY

Yet it would be a mistake to set aside our daily experience completely when thinking about portraiture. Human beings respond to each other's visual stimuli in complicated ways without being aware of it. It is helpful to remember that we recognize people through a wide

variety of mechanisms, not just the appearance of their faces and bodies, which is what has generally been privileged in portraits, but also their gaits, postures, and expressions. What is particular about a person is extraordinarily subtle, and artists who work directly with sitters respond to such individuality in historically specific as well as idiosyncratic ways. It is clear that over the last four centuries the ways in which we have thought about and represented human individuality have changed markedly. For example, notions of personality have come into being, and we now have a psychoanalytic framework available to us. In the present day, it is commonly assumed that people have many layers of consciousness, that much in their minds is hidden and repressed, and that they have depths

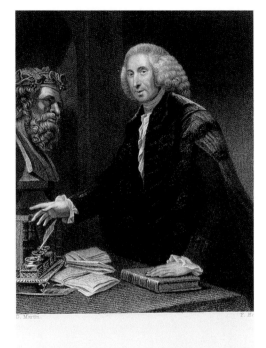

4 Portrait of William Cullen with a classical bust, from T. J. Pettigrew, *Medical Portrait Gallery* (1838–40).

Pettigrew's publication combines biographies with fine engravings. A protégé of John Coakley Lettsom, he was both a medical practitioner and an enthusiastic historian. William Cullen was a major figure in Enlightenment Edinburgh whose extensive influence was felt largely through the many medical students he taught.

5 John Jabez Mayall, *Sir John Herschel, 1st Bt, c.* 1848, daguerreotype, 8.6 × 7 cm.

John Herschel, William Herschel's son, was famously photographed by Julia Margaret Cameron. This daguerreotype, which deploys the familiar head-on-hand pose, conveys the sense of a prominent and self-assured man who played a significant role in the 19th-century scientific establishment.

and contradictions which should be alluded to pictorially if possible. Dramatists, for instance, have been exploring these issues for centuries, although the older idea of 'character' is quite distinct from the more recent one of 'personality'. Furthermore, assumptions about how, say, dress and hairstyle contribute to portraits have changed markedly over time. Such changes are most evident in styles of representation we might call 'naturalistic' in that they claim to do justice to the observable world. There are portraits that make no such claims and that are visibly formulaic. Nonetheless, even more iconic images have to respond to the status of individual sitters, which is peculiar to them. Individuality does not have to be construed in terms of personality. Artists can allude to their subjects' distinctive traits in a number of ways – for example, via symbols of their status and accoutrements, an aspect of portraiture to which we shall return.

To restate the argument so far in terms of identity: portraiture is an extremely important means through which identity is constructed. It constructs not just the identity of the artist and the sitter,

United Kingdom of Great

Passport Passeport P

Type/Type

Surname/Nom (1)
COEN

Given names/Prénom
ENRICO

Nationality/Nationalit
BRITIS

Date of birth/Date de
29 SEP

Sex/Sexe (6) P
M L

Date of issue/Date de
03 MAY

Date of expiry/Date d'
03 MAY

P<GBRCOEN<<ENRICO<SA

6 Partial page of Enrico Coen's passport, 1994.

Enrico Coen is a geneticist with a particular interest in the visual arts. He has painted a number of portraits of fellow scientists, and his 1999 book *The Art of Genes* explains recent developments in his field using metaphors drawn from the production of art.

7 Godfrey Argent, *Sir Geoffrey Allen*, 1977, photograph.

For some time, the Royal Society has maintained a collection of photographs of its Fellows. Sir Geoffrey Allen is a chemical physicist who has also enjoyed a career in industry. He became FRS in 1976.

but that of institutions with which they are associated. Portraiture is just one highly artificial means by which, in some societies, individual and collective identities are forged. Thinking about daily life can enhance our awareness of the wide range of situations in which a person's identity matters, and of the forms such identity takes. We might consider occasions when a signature is required, for instance (illus. 4). Signing one's name has long been a significant act. Signatures have a special status in art practice: they affirm the identity of the artist, her or his value, and, by extension, the value of the work itself. In the nineteenth century, portraits were often reproduced with the *sitter's* signature underneath it – a further affirmation of who they were, of their particularity. In modern times, a signature authenticates a person's identity; it is a sign not only of assent to a specific proposition but of a more general good faith. Signatures and trust go hand in hand. It is important to recognize that not all these aspects of identity are benign. People often sign papers they do not fully understand or assent to; their picture can be used, as so many commentators have noted, for the purposes of surveillance and control. Keeping pictorial records of the insane, suspects, criminals and the inmates of penal institutions became common during the nineteenth century thanks largely to the development of photography. Photography has had an immense impact not just on portraiture as an artistic genre, but on everyday practices that relate to likeness and identity (illus. 5).[3] However, photofits and passport photographs are probably not to be considered as *portraits* in the fullest sense (illus. 6, 7).

USES AND IDENTITY

Portrait has an air of formality to it; it conjures up both a pose, for a specific purpose, and a maker, someone who is more than a friend, relation or casual acquaintance. Holiday snaps are not normally thought of as portraits, and it would be usual to distinguish between a photographer who takes wedding and family pictures for a living

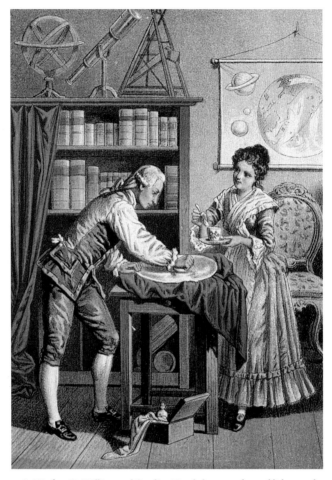

8 A. Diethe, *Sir William and Caroline Herschel*, 1814, coloured lithograph, 34.7 × 25.7 cm.

This fanciful reconstruction of the Herschel siblings at work reveals more about a prettified retrospective image of the 18th century than about that period itself. Is this a portrait?

and one whose work is exhibited in an institution such as the National Portrait Gallery. These examples suggest two significant issues. The first is the huge change that the development of photography has brought about in the representation of specific individuals. Photography has made supposedly truthful images of people

commonplace, with the result that it is hard for us to imagine a world in which authoritative depictions had significant scarcity value and the literalism of photography was not the norm. The second issue involves the changing and varied uses to which portraits are put, which shift not only over time but also with class, gender and professional background. Portraits are used to effect all kinds of business in the world. In so far as it is productive to think of them in this way – as gifts, mediations, relics, tokens, objects of exchange, fetishes – they are inseparable from the concept of identity. Accordingly, I would now like to probe this notion a little further.

Identity in its simplest descriptive sense means the factual aspects of who a person is – their name, date of birth and address, obviously, and also their occupation and kinship relations. But it is immediately apparent that more subjective elements are always involved in full definitions of identity, such as where one comes from and how one thinks of oneself. These are never as simple as the phrase 'where one comes from' reveals. Is this a matter of geography, ethnicity, race, education, ancestry or religion? Is it a subtle and shifting combination of factors, or do the key aspects of identity reside within a person's biological make-up? Is it controlled by the individual or produced out of elaborate social interactions? These less tangible aspects of identity are composed of a number of elements, some of which may be in tension with one another, and they seem to shift according to circumstances and over lifetimes. Political conflicts and debates in many countries hinge on matters of identity such as religion and ethnicity; hence individuals are subject to larger forces.

In relation to portraiture, two immediate issues arise. First, how are such complexities translated into and expressed in visual form? We will explore this issue in greater depth in Chapter II, which raises questions about how those who produce special kinds of knowledge are depicted at a given time. And later in this chapter, we will consider images of the learned man – one paradigm that is particularly relevant to scientists and doctors – in which the sitter's identity, in its

broad sense, is displayed. The second issue is exceptionally challenging. In the making of a portrait, at least two individuals come into a complex relationship – what is sometimes called the portrait transaction. And in each case, their identity will be a complex amalgam of internal and external factors. In other words, there is always a negotiated relationship between a subjective sense of self and the possibilities offered by the world in which it exists. Accordingly, each individual's identity is a composite that is likely to shift over their lifetime and according to circumstances. Portraiture brings, at the very least, two such identities into a potentially close, if temporary, relationship that is conducted according to the expectations of the commission and those involved with the making of the image, and also to the relevant conventions. In human as in artistic terms, it is an extraordinarily dense encounter, which we will probe further in Chapter IV.

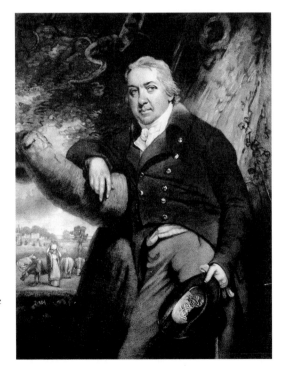

9 John Raphael Smith, *Edward Jenner*, 1800, mezzotint 45.2 × 35 cm.
 John Raphael Smith was a prominent and prolific engraver, well known for his mezzotints: here he was both the original artist and the print-maker. Smith also engraved portraits of Joseph Banks and Erasmus Darwin.

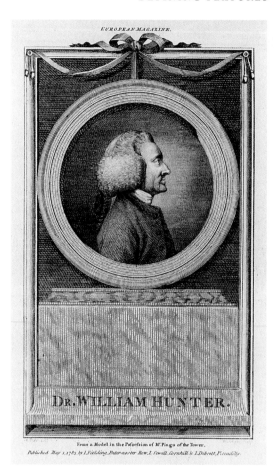

10 W. Angus after Miller, *Dr. William Hunter*, 1783, line engraving, 15.9 × 9.6 cm.

This image, published in the *European Magazine* just after Hunter's death, is typical of the portraits that appeared in 18th-century magazines, especially in its surround and lettering.

The complexities of identity are particularly obvious in the case of portraits with a professional dimension. The 'job' is presumably to the fore – but what about women, like Caroline Herschel, who were quite exceptional for their time (illus. 8)?[4] Herschel was a woman scientist at a time when such beings were rare. She was known by virtue of her collaboration with her brother William, who emigrated to England from Germany as a young man and spent the rest of his life there, first as a musician and later as an astronomer, becoming a prominent member of English society and obtaining a court appointment. Caroline Herschel was also thought

of as notable because she attained a great age, retaining her faculties and good health. So, there are a number of ways in which she, her contemporaries, artists and we can imagine her identity, and they are *not* seamlessly interwoven with one another. I put 'job' in inverted commas to signal that even this is a problematic idea. As we shall see in Chapter II, occupational categories have changed a good deal since the mid-seventeenth century. Indeed, until the twentieth century they were markedly fluid. One way in which they could be explored was by including specific objects and visual references in a portrait. For example, many artists who depicted Edward Jenner, hailed as the discoverer of vaccination against smallpox, included references to cows or to smallpox in their images of him. Jenner was a surgeon, a natural historian, a man of science and a country squire, so his social and occupational position was hardly simple (illus. 9). Nonetheless, most artists made visual reference to his publicly acclaimed achievements. But it was also possible to avoid such references altogether, a strategy that had its advantages, especially if, as in the case of William Hunter, the public reputation included activities – man-midwifery and anatomy – that were highly controversial (illus. 10, 96, 97).

CONTEXTS

In order to gain a deeper understanding of how scientific and medical portraits have been used, it is necessary to recognize that portraits never exist in isolation, but need to be seen in multiple contexts. We can distinguish four types of context. The first is portraiture practices in general. Artists will be aware of the work of their forebears and contemporaries, and will be having conversations with them, more or less explicitly. Second, the social networks within which practitioners of science and medicine functioned not only help to explain why one artist rather than another was chosen, how the commission was managed and where the portrait would be hung, but also the visual idioms selected. Third, pictures and

texts are closely related, so that discourses, such as biography, gave portraits further settings and meanings. Finally, portraits always need to be seen in the physical contexts for which they were made – for example, the public settings, such as institutions, through which they acquired associations and significance. There was considerable overlap between these contexts. A portrait in profile and evocative of a medal, appearing in a magazine along with an obituary, for example, needs to be understood through multiple contexts.

A number of the contexts in which portraiture appears relate to phenomena we designate 'public'.[5] The use of the slippery term *public* demands careful thought, however. We can consider publications as one aspect of this issue. Portraits were used as frontispieces to published writings on natural historical, natural philosophical and medical subjects, as indeed they were to writings in other areas. In this way, portraits of people with diverse talents and achieve-

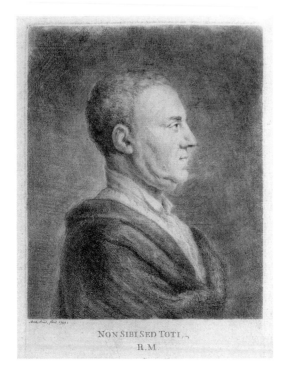

NON SIBI SED TOTI,
R.M.

11 Arthur Pond, *Richard Mead*, 1739, etching, 25.4 × 18.5 cm.

Portraits in profile evoke antique coins and medals. Mead's Latin motto, which roughly translates as 'Not for himself but for all', further reinforces the classical reference.

ments could be compared with one another and with earlier, para-
digmatic depictions, such as those of the ancients. A good example
of this point would be Arthur Pond's portrait of Richard Mead, the
early eighteenth-century superstar doctor, with its unmistakable
classical allusions (illus. 11). A similar portrait of Alexander Pope, who
was a friend of Mead's, has been attributed to Jonathan Richardson.
A member of the Royal Society, Pond, like Pope and Richardson,
moved in the same circles as Mead, circles in which classical learning
was highly valued. (Mead did not like this particular image, how-
ever.) The most prestigious portrait of Mead was executed in the
grand manner by his friend and protégé, the Scottish painter Allan
Ramsay, for the London Foundling Hospital of which Mead was
a Governor and in which he took a close interest (illus. 12). Also
closely involved with this philanthropic enterprise was William
Hogarth, who painted a splendid portrait of the hospital's founder
Thomas Coram (illus. 13). Thus we can see immediately how im-
portant social networks were in bringing artists and their sitters
together and also in providing occasions for the *display* of portraits,
as the Foundling Hospital did.[6] There was considerable public
interest in this institution; thus those involved with it were in a
certain sense public figures.

Yet portraits do not only function in relation to other visual expe-
riences; they gather meanings from writings with which they are
associated. I would argue that, for most of the period with which
we are concerned, portraiture needs to be placed in the context
of biography, which became an increasingly popular subject over
the course of the eighteenth century, although it was certainly not
invented in that period. Of particular significance were periodical
publications, especially those produced by specialized institutions in
whose interests it was to revere their own. But general magazines
also arose during the eighteenth century, that regularly carried
biographical notices, sometimes around the time of the subject's
death, accompanied by a portrait (illus. 10). To a degree these were
'public' settings. The whole point about a publication, unless it is

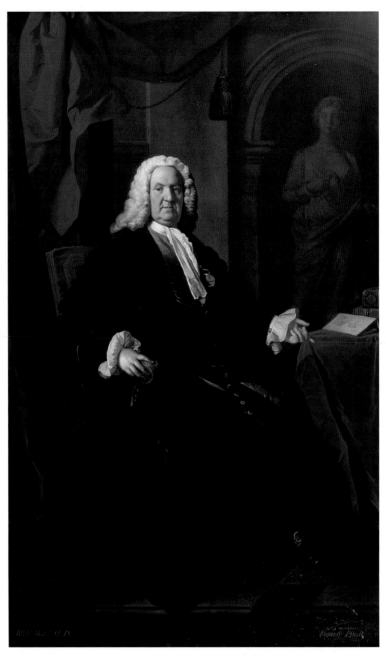

12 Allan Ramsay, *Portrait of Richard Mead*, 1747, oil on canvas, 236.7 × 144 cm.
This magnificent 'grand manner' portrait was much admired by contemporaries,
who thought it an excellent likeness.

13 William Nutter after William Hogarth, *Captain Thomas Coram*, 1796, stipple engraving, 57.4 × 41 cm.

Hogarth's 1740 portrait of his friend Coram, the main force behind the creation of a Foundling Hospital in London, was turned into many prints during the 18th and 19th centuries. It somehow manages to elevate its subject while showing him as unaffected.

produced in extraordinarily small numbers, is that it reaches people beyond personal networks. As a commodity, it can be bought by anyone with the requisite funds and an interest in its contents.

In a quite particular sense, portraits in institutions were public in that they were seen by anyone who frequented the organization in question. However, they were not available to literally everyone; on the whole, what we now call the *general* public did not have access to them. This is still the case. The major institutions in which scientific and medical portraits are held – such as Oxford and Cambridge colleges, the specialized colleges and societies such as the Royal College of Surgeons, the Geological Society, and national institutions such as the Royal Institution or the Royal Society – are not

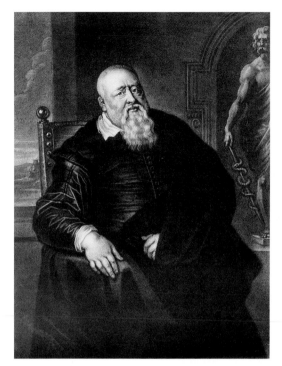

14 Jean Simon after Sir Peter Paul Rubens, *Theodorus Turquetus Mayernius...*, c. 1753/4, mezzotint, 35 × 25.5 cm.

Born in Switzerland to a French Protestant family, Turquet de Mayerne lived in England for much of his adult life. He was a physician to Henry IV of France and to James I and Charles I of England. Richard Mead likewise was a physician with royal connections; similarities between this portrait and Ramsay's depiction of Mead are not coincidental.

open to the public in the same way as major museums are. Few probably would deny access to those with a special interest in their holdings, but the sense in which they are 'public' is quite specific. Nonetheless, 'public' is a useful notion here, even if I am giving it a very particular cast. It certainly helps us to think about the contexts in which portraits of 'scientists' existed in the past. Audiences are an important part of any such context.

Let's return briefly to Richard Mead, who possessed extensive collections of paintings, prints, drawings, statues, medals, books, coins and so on, and who welcomed those interested in them to his home in order to view and study them. We think of houses as 'private' settings, yet this is anachronistic. The homes of many learned men were places to meet and discuss. In Mead's case, there was a dining club that brought together artists, antiquarians, natural philosophers, physicians and scholars.[7] It is true that Mead was

unusually generous with his collections, but this blurring of the boundaries between 'public' and 'private' was by no means unique. As a result, there were many places in which portraits could be viewed and reproduced. Mead owned a portrait by Rubens of a famous seventeenth-century physician, who, like Mead himself, had held a court appointment. A mezzotint of the portrait mentioned its provenance from Mead's collection (illus. 14). Such prints circulated in similar ways to books, and in this case the print served to make a number of connections, between people and between ideas, accessible to a wider public. The erection of memorials, in St Paul's Cathedral or Westminster Abbey for example, was another way in which representations reached the public. These too were reproduced as prints (illus. 15).

We need to recognize that there are audiences and publics; the plurals are important. Sometimes, scientific and medical portraits

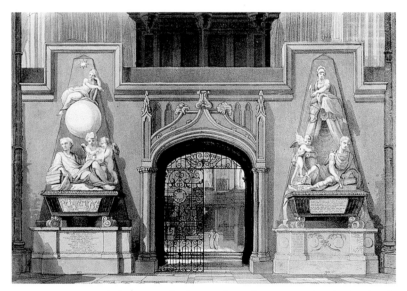

15 Augustus Pugin and Thomas Rowlandson(?) after William Kent and Michael Rysbrack, *Sir Isaac Newton's Monument*, 1812(?), coloured aquatint.

Newton's memorial in Westminster Abbey (left), an important church monument in its own right, was a visual symbol both of scientific achievement and of the public recognition of that achievement.

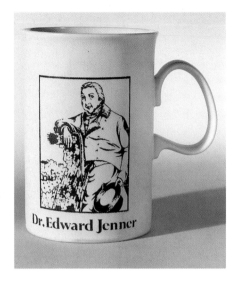

16 This porcelain mug decorated with an image of Edward Jenner derived from John Raphael Smith's portrait (illus. 9, 60) is on sale at the Jenner Museum. Portraits are now a familiar component of many commodities; interestingly, this trend was already apparent in the 18th century.

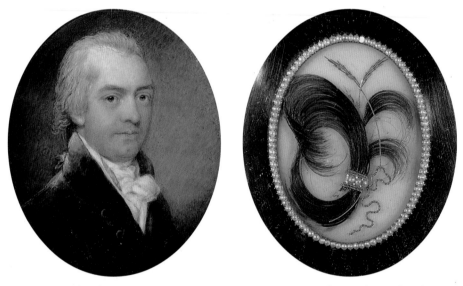

17 Joseph Robinson(?), *Robert Willan*, 1808, miniature on ivory (obverse), hair and seed pearls (reverse), 7.4 × 5.7 cm.

This exquisite miniature is one of a pair; its pendant depicted Robert Willan's wife Mary. Willan was a medical practitioner with wide interests and a particular concern with diseases of the skin.

are made for these communities, who constitute mini-publics as it were. Yet once an object is created, it takes on a life of its own and can be turned into many different forms. Accordingly, we are not just considering painted portraits here, but medals, waxes, prints, statues, miniatures and, in more recent times, photographs, banknotes, stamps and so on. It is important to remember that with the advent of printing technologies, multiple reproductions from a single 'template' became possible, and this proliferation often occurred in the case of the great heroes of science such as Edward Jenner (illus. 16). I have mentioned the importance of the diverse uses to which portraits can be put, and each physical form can be turned to a somewhat different set of uses. Miniatures, which can be carried around, are clearly more intimate objects than memorial statues, and their uses, like their settings, vary accordingly (illus. 17).

SACRED SETTINGS

Portraits take on significance from their surroundings. The erection of an elaborate memorial to Sir Isaac Newton in Westminster Abbey is often referred to as a significant turning point in Britain (illus. 15; compare illus. 18). Many people connected with the practice of science and medicine are commemorated in churches and cathedrals – Edward Jenner, James Watt and Charles Darwin, for example. Such memorials often, but by no means always, involve portraits (illus. 32).[8]

Putting such achievers in a religious setting has a number of implications. It is particularly hard to generalize over a long time period, but we should bear in mind the significance of an implied association between science and the religion recognized by the State. Such memorialization was not available to dissenting or Catholic scientists, and it is interesting that Newton, who held heterodox religious views, admittedly carefully concealed, was celebrated in such a public way. There is no doubt at all that a place in Westminster Abbey or St Paul's was understood as a mark of honour, respectability and national significance; it therefore

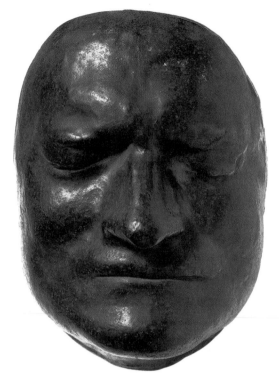

18 John Michael Rysbrack, Death mask of Sir Isaac Newton, 1726, iron cast, 19.7 × 14.6 cm.

The existence of a death mask of Newton (a version of which is in the Royal Society) indicates the veneration accorded him at the time of his death.

communicated to a wider public assumptions about the status of natural knowledge and of particular practitioners in society as a whole. Such recognition implies an acceptance of the general value of scientific, technological and medical activities.

There is a further point to be made about connecting science with sacred spaces. Reverence and awe would seem to be plausible expected emotions, although it is vital to remember that churches were already places of mass tourism in the eighteenth century. There are two reasons to mention this point. Although we live in a sceptical age, a certain amount of reverence towards modern science, technology and medicine is simply taken for granted. To take one emotive issue, hostility towards and anxiety about genetic modification co-exists with ideas of boffins and scientific geniuses and of virtually unlimited progress that will make life better. But

this reverence was hard won. Historians of science are studying the long, drawn-out processes as a result of which the status of both natural knowledge and those who create it were elevated. Therefore, we should never take such reverence for granted.

Another reason for mentioning sacred settings concerns the common claim that science has displaced traditional religion to become a new creed in its own right, with scientists as a new priesthood. Although broad questions about the relationships between science and religion are beyond the remit of this book,[9] they are nonetheless relevant to the history of scientific portraiture. Portraits reveal the status and value of specific groups, not just in the way they are composed but in their formats and media, in the forms of reproduction they undergo, the places in which they are displayed and the uses to which they are put. More specifically, we can compare science with other domains and get a sense of how it is valued at any given time. The long-standing concern about science and religion, which has taken so many different forms, is a major aspect of the public face of science, to which portraiture makes a significant contribution. This concern has formed a backdrop to debates about the status accorded those who make important scientific and medical innovations, as we shall see in the case of Edward Jenner, of whom a statue stands in Gloucester Cathedral. I do not assume any innate tension between science and religion; indeed, the drift of my arguments is rather in the opposite direction. By placing representations in religious settings, the public value of science was affirmed by a sector of the Establishment.

ANALYZING PORTRAITS

If the public status of science was hard won, and if depictions of practitioners were a significant factor in its wider image, then the *precise* form such representations took was of vital importance. We can analyze any portrait into a number of distinct components in order to understand how this worked in more detail. In fact,

portraits, like other images, work on their viewers in a great variety of ways, which interact subtly in any given instance. A number of the most significant features have already been mentioned. The following list illustrates some of the issues that should always be raised in relation to any portrait (in addition to the obvious ones involving the identity of sitter, patron and artist, date and provenance): size, medium, proportion of the body represented, presence or absence of accoutrements, the palette, the pose, the proportion of the canvas taken up by the sitter, dress, hair, background, frame, intended location. We also need to ask about how the image came into being and about the existence of related images.

This is a good point at which to confront a number of prejudices about portraiture, which are widely held today (and have been for some time), but which do not necessarily apply to earlier periods. At its foundation in the middle of the nineteenth century, the National Portrait Gallery in London established an acquisitions policy that laid emphasis on authenticity.[10] There were two main ways in which this commitment manifested itself: portraits had to be done during the lifetime of the sitter, and the portrait could not be a copy – it had to be the 'original'. I put 'original' in inverted commas for two reasons. It can be extraordinarily difficult to tell which is *the* original, and in order to undertake such a discrimination, experts make a whole range of assumptions about artistic practices and hierarchies, including the way studios (i.e., art workshops) functioned and how artistic skill was measured. The very notion of an original contains implicit claims about how artworks are valued. One implication is that a single, named artist produced one finished version of a portrait that may legitimately be given privileged status. This single version is the most valuable one, artistically, historically and financially. In other words, authenticity and singularity go together. But in studio settings where each canvas or object is worked on by a number of hands, these assumptions simply don't fit. An elaborate division of artistic labour has the potential to mess up neat and tidy assumptions about originality, skill and individual creativity.

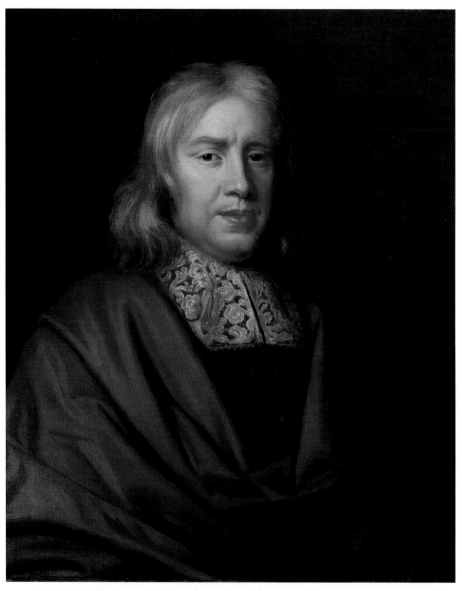

19 Mary Beale, *Thomas Sydenham*, 1688, oil on canvas, 76.2 × 61 cm.

Sydenham, sometimes dubbed 'the English Hippocrates', was much celebrated by later generations of medical practitioners, especially for his devotion to careful clinical observation. A political radical, he never joined the Royal Society. He and Mary Beale were neighbours; this painting is thought to be one of her best works.

Furthermore, the need to make multiple versions of a given portrait was frequently taken for granted. Contemporaries did not necessarily value an image less for being a 'copy', or one of a number, since it nonetheless carried significance as a token of a valued person, a valued token if it was thought to convey their special qualities with particular effectiveness. The connotations of the very word *copy* are unfortunate, as it implies mindless imitation, a mere derivative, something second-hand. I am not saying that issues of skill are unimportant. There are copies of major portraits that are, artistically speaking, far inferior to the original. Nonetheless, historians need to think about why they were undertaken, and how they were used and valued. There are, of course, different types of copy. On the one hand, in the case of a painting, there can be other paintings that very closely resemble the template. On the other hand, prints derived from a painting clearly differ from it, yet can be seen to resemble it in certain specific ways. Many different prints could be derived from a single painting or, indeed, from a sculpture. The kinds of copies involved in these two cases are very different.

The question of copies also raises the difficult issue of hierarchies of media. We tend to think of oils or marble sculptures as occupying privileged positions compared to, for example, sketches, prints or waxes. This is because the former are closely associated with canonical works of art, whereas wax modelling, for instance, has little status within a traditional artistic canon. It is best to put such assumptions to one side in so far as this is possible, and to consider instead the value given to works by those who made, bought and used them. Equally, there is a hierarchy of genres in which portraiture tends to come rather low down. The status of various artistic genres is a complex matter, but one problem with portraiture is that it refers so quickly to a person other than the artist, and the artist's job can be construed as mere 'face-painting'. If we are thinking about the seventeenth to early nineteenth centuries, capturing a likeness can be seen as less artistically creative than working in 'higher' genres such as history painting. Perhaps the

fact that portraits were copied so often lessened their collective status.[11]

The precise chronology of related portraits is of paramount importance, as are the visual changes involved in each transformation. Listing the different factors that contribute to the overall appearance of an image should help us to recognize how subtle and varied portraits are even when they depict a single person or are produced at the same time. Accordingly, there are no simple generalizations to be made about matters such as accoutrements and dress, no unambiguous chronological shifts.

When analyzing scientific and medical portraits, we need to be particularly attentive to two of their features, even if these do not

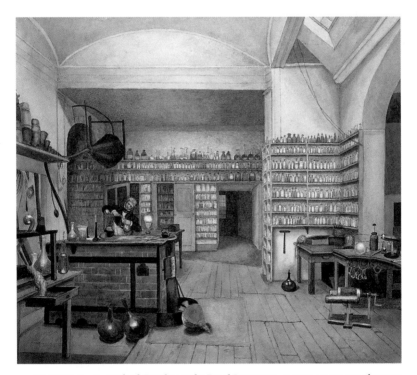

20 Harriet Moore, *Michael Faraday at the Royal Institution, c.* 1850–55, watercolour on paper, 41 × 47.2 cm.
This unusual and delicate image showing Faraday in his laboratory is noteworthy because there had been few depictions of men of science at work.

follow any simple patterns. The first is the presence of accoutrements specific to the kind of knowledge the sitter produced. Unidentifiable papers and books would not be such an accoutrement, but a book whose author and/or title was legible certainly would. Instruments would be another example, although these were relatively rare before the nineteenth century. In the eighteenth century, a bust of an illustrious forebear, such as Hippocrates or Galen for medical practitioners, or a recognized symbol like the caduceus, conveyed not just information about the sitter but a sense of their distinctive and venerable achievements (illus. 4). The second and sometimes closely related feature is the setting in which the subject is placed. For a long time, settings were relatively unspecific; a room, drapery,

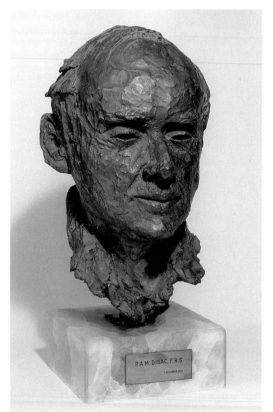

21 Gabriella Bollobas, *Paul Dirac*, 1973, copper, h: 35.6 cm.
Dirac became a Fellow of the Royal Society at the age of 28 and three years later won the Nobel Prize for physics jointly with Erwin Schrödinger.

a column and a fine chair were all relatively common. A table could be used for specimens or a special object, such as Sir Humphry Davy's safety lamp (illus. 57). During the nineteenth century, more specific settings, including places of work such as laboratories, entered some pictures (illus. 20). It is important to remember that, striking as many portraits that contain such settings are, large numbers of other scientific and medical portraits contain no such details (illus. 21). So, all we can say is that these details have become more accepted over time, but they are by no means a requirement of a contemporary portrait, many of which concentrate on the sitter's face. Not surprisingly, specifically scientific, medical and technological settings tend to be more evident in photographs – where it is easy to show practitioners *in situ* – than in oils.[12]

REPRESENTATIONS OF LEARNING

There are, however, some persistent tropes. For much of the period with which this book is concerned, scientists were associated with learning and scholarship. I would argue that this association is no longer dominant, although it sometimes comes up in relation to mathematicians, where the thinking aspects of their practice can be emphasized. But for many centuries, the equivalents of today's doctors and scientists were precisely thinkers. There were a number of pictorial conventions for representing a man who thought.[13] Setting was one: a study-like environment, the possession of books and so on. A sense of isolation from the world was another: a single figure set apart from the crowd, from human communities, in a cave or lonely place, for example. The most obvious convention, however, was the head-on-hand pose, with the subject seated near books, one elbow resting on a table and the hand propping up the face, which was depicted as pensive (illus. 22).

This pose, a particularly renowned example of which is Albrecht Dürer's print *Melancholia*, is to be found in many portraits from subsequent centuries and not only in scientific and medical contexts.

Its implications are complex. It was certainly an important device from 1660 until the 1820s roughly speaking, and was used to suggest that those who studied nature and humanity were educated and thoughtful. It associated such people with ancient traditions, with hermits or reclusive saints. The man of learning was a recognized social type; while it certainly did not connote social dominance or power, it did evoke a certain respect. It seems to me that medical practitioners, whose occupational activities were particularly problematic in being (especially in the case of surgeons) both manual and potentially transgressive, were quite keen to be seen as possessing mastery of non-manual – that is to say, intellectual – skills. There were heated debates about the value of learning, and, over the course of the eighteenth and nineteenth centuries, scientists constructed arguments about the usefulness of their particular kind of knowledge.

Thus the role of 'man of learning' had strategic advantages, but it also had limitations. In so far as it suggested a separation from the everyday world, it undermined the claim of men of science to be at the forefront of social change that would benefit humanity as a whole. The trope of melancholy, inseparable from conventional depictions of learned men, had a further disadvantage. It evoked introspection, even depression, a lowness that comes from being too much inside oneself. To have a highly refined mind suggested the possibility that one was over-sensitive, even self-obsessed.[14] A particularly interesting instance of this issue is James Watt, who did indeed suffer from depression and was shown in (some of) his portraits as evidently melancholic. Although Mary Shelley used this predisposition to self-obsession to suggest that her fictional 'hero' Frankenstein was irresponsible in the way he used his knowledge, Watt's real image did not suffer unduly by the association. We should not infer from this that melancholy was unproblematic, but that each individual's portraits functioned in a distinctive way even as they drew upon established conventions. This is precisely because depictions of an individual are interpreted in wider contexts,

especially discourse, which is precisely what happened in the case of Watt (illus. 32). Despite looking seriously depressed, he could be understood in positive terms as modest and unassuming.[15]

INDIVIDUALS AND GROUPS

In this book, I shall be concentrating on images of individuals rather than of groups, and it may be worth examining the distinction in greater detail. I have just alluded to the idea of the learned man as solitary, even hermit-like; of course, this is not a *description* of how learning was actually carried out but a *created* image. The relationships between individuals and groups are all the more important because I have chosen 1660, the year in which the Royal Society was founded, as a start date for my considerations (illus. 24). The Royal Society from the very start involved collective activities such as experiments. Indeed, its basic premise was that natural philosophy could best be advanced by organizations. Its publications, especially the *Philosophical Transactions,* merely reinforced the point that exchange and collaboration were important for 'the advancement of learning', to use Francis Bacon's phrase. Bacon was frequently invoked by later generations in support of the idea that natural philosophy was best pursued by groups of like-minded men and that the results would be of general value.[16] Yet – and here we must remind ourselves once again of the gaps between practices and representations – there are relatively few depictions of scientists in or as groups before the mid-nineteenth century. Sometimes, they were shown with their families, as was John Coakley Lettsom, although not usually in 'official' portraits.[17] But learned societies and other organizations did not generally commission group pictures. In this sense, the well-known painting by Rembrandt *The Anatomy Lesson of Dr Tulp* needs to be understood in a highly specific context; it did not have many imitators in Britain.[18] A similar argument might be made for Johann Zoffany's depictions of William Hunter teaching anatomy at the Royal Academy of Arts. Zoffany's

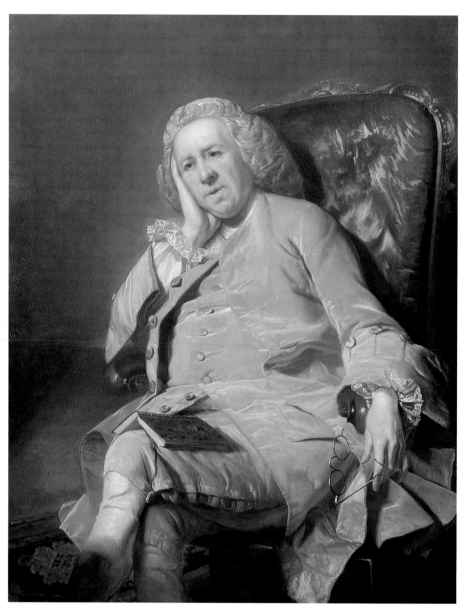

22 Mary and Thomas(?) Black, *Messenger Monsey*, 1764, oil on canvas, 127 × 101.5 cm.
 Little is known about Mary Black. This wonderful portrait of a well-known 18th-century eccentric both deploys the head-on-hand trope of the learned man and subtly subverts it.

works need to be placed in the context of depictions of *artists* being trained or learning together, in life-drawing classes for example.[19] In the British context, a key work is the print, published in 1862 after a long gestation, entitled *The Distinguished Men of Science of Great Britain, Living in A.D. 1807/8*, which was made up from pre-existing images of individuals. They are shown in the library of the Royal Institution in Albemarle Street, London, into which many of them never ventured. In this sense, it was a fictitious group.[20] However, during the nineteenth century, groups of men of science and of medical practitioners began to be represented in a number of contexts, and photography, which could record those attending national and international meetings and gathered in their places of work, further reinforced this trend.

The importance of individual representations needs to be put in the context of assumptions about genius, heroism and the nature of intellectual advancement, many of which persist today. Despite the growing significance of collaborative work in the twentieth century – laboratory-based science is essentially done by teams – the emphasis on the individual remains. Nobel prizes are not awarded to teams but to individuals. Discoveries are generally linked with individuals who give their names to objects, ideas and processes, and the concern about establishing priority in such matters remains strong (illus. 23). For centuries, most scientific publications were produced by individuals, so ideas were attached to them rather than to networks or groups. This is not a complete account of actual practice but a statement of conventions, which, even as they have changed, have reinforced a sense of the importance of the individual in science. Furthermore, portraits of individuals were designed to be exemplary – that is, they were intended to inspire others to work hard, to achieve and to prompt admiration in viewers. They were living reminders of what could be done. They also purport to be records, so that highly abstract achievements, which the majority of any population does not understand, are given a stable foundation in the bodies of achievers.

23 Ramsey & Muspratt, *Dorothy Mary Crowfoot Hodgkin*, c. 1937, bromide print, 37.8 × 30.1 cm.

Ramsay & Muspratt photographed many of the leading intellectuals of their time, especially those on the political left, such as the crystallographer J. D. Bernal, with whom Hodgkin was closely associated. Hodgkin, who won the Nobel Prize for chemistry in 1964, remains the only British woman to have won a Nobel for science.

Between 1660 and 2000, the sheer number of portraits grew dramatically, and portraits also took on a variety of physical forms. We need to resist the temptation to follow traditional hierarchies of artistic production when it comes to studying the rich diversity of scientific and medical portraiture. Although we have to be careful when it comes to photography, since many photographs of people are not what would normally be called portraits, it is clear that this technology transformed attitudes to representation. For example, photography offered the promise of a uniquely authoritative likeness and made 'accurate' representations more freely available, even commonplace. However, it does not follow that artistic conventions became less important. These were – and are – always central to portraiture, which is a specific form of art. At any given time, artists have a limited number of conventions available to them. And if they are depicting a specific occupation, there will be further constraints, on pose, accoutrements and setting for example. These constraints will vary from time to time and sitter to sitter.

Conventions are mediated in a number of ways. The role of

patrons was crucial. Sometimes, scientists commissioned their own portraits, although direct evidence of the commissioning process can be hard to obtain. Many portraits were designed to be hung in institutions, with the result that the meaning of any particular one will be better elucidated by placing it within larger sequences. Equally important for understanding the working out of conventions is the relationship between artist and sitter. It is striking how many artists were in the same social circles and/or intellectual networks as those they portrayed. This is of interest because it suggests that artists had some direct knowledge of and sympathy for the complex positions held by their sitters, especially in periods of what we could call occupational fluidity, when there were few professional structures and the class status of many scientists was somewhat ambiguous. The point applies especially to depictions of women practitioners, whose status is invariably rather complex.

We can put many of these points in another way if we insist that portraits are always art – that is, they are not neutral depictions of a state of affairs in the world but creations of the artist's imagination that respond to a challenge within historically-specific constraints. In making a portrait, artists are thinking not just of the person before them, assuming they are working from life, but of other artworks, of their own works, of their contemporaries, and they are also responding to specific sitters and patrons. These complex processes have been occurring in British culture for hundreds of years. It is simply assumed that pictures participate in the construction of identity. Hence, when individuals and groups are especially concerned about their public face, it is overdetermined that they will use portraiture as a tool. Once created, portraits can be put to many different uses over which the original participants have no control and which they could not possibly have imagined.

Portraits, then, have become integral parts of many social processes. Collectively, we buy into the fiction that we can know people by looking at likenesses of them. We need to be simultaneously critical of this idea and sympathetic to its grip.

47

II

BOUNDARIES

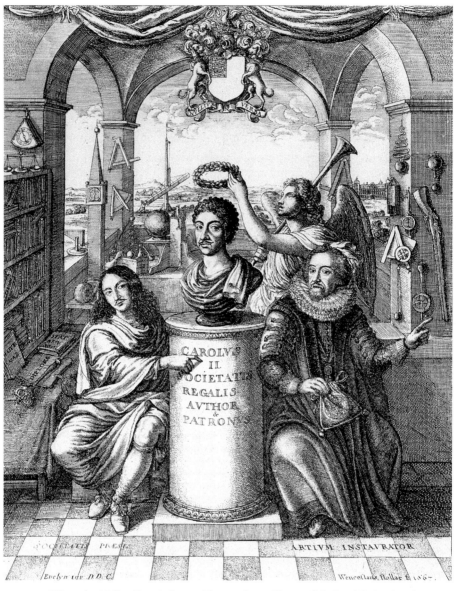

24 Wenceslas Hollar, Frontispiece to Thomas Sprat, *History of the Royal Society* (1667), etching.

Sprat's volume was designed to show the Royal Society in a positive light. The frontispiece is based on a design by John Evelyn and, significantly, includes Francis Bacon, who was an influential thinker as well as a powerful political figure. Fame is crowning a bust of Charles II. The figure on the left is Lord Brouncker, the Society's first President.

We should begin with an honest appraisal of the terminological minefield surrounding the practice of science, medicine and technology. One aspect of the problem was alluded to in Chapter 1 in connection with the word *scientist* and its relatively recent history. Sometimes, words like this are used for convenience, even when they were not current in the period under discussion. However, it is important to be aware of changing vocabularies because they reveal significant historical shifts. The narrowing down of 'science' from systematic knowledge in general to one specific type of knowledge is a case in point. Our purpose here is to reflect upon the portraiture of certain groups of people; hence we need to be clear about how those groups were defined and named, why individual members were represented and in what capacity. Such clarity will also be helpful in thinking about sitters' identities. Everyone uses language as a basic means of experiencing the world, and the way in which a person is described, both by themselves and by others, is of fundamental importance.[1] What anyone does is a central part of their identity. Nonetheless, we can immediately sense further problems of terminology.

Science as a structured, paid career is a relatively recent phenomenon. Many people have created natural knowledge without such a framework. So how are people who work without payment to be described? As amateurs, perhaps, although this can suggest activity that fails to meet the very highest standards of what we would now call professionalism. Yet 'amateur' also means one who does something for love. Is such commitment usefully opposed to professionalism? How, then, is 'profession' to be defined? It is a veritable minefield.

We can break these difficulties down into three issues: the changing nature of work itself; the specific problems raised by the domains now called science, medicine and technology; and the ways in which identities are built around such activities. Profound historical changes have shaped all these areas over the last three hundred years or so. The organization of work, including the division of labour, education and training, institutional control over occupations and sources of energy for industrial production, have undergone huge transformations which form the context in which we need to understand changing depictions of practitioners. Here they can be alluded to only in passing, but they do have one rather important implication for the portraits I discuss.

In what sense are there continuous historical phenomena to be charted from 1660 to the present day? Is it meaningful to think of a portrait of an early member of the Royal Society, such as Christopher Wren or John Evelyn, in the same context as images of those who became Fellows after the Second World War (illus. 25, 26)? My

25 David le Marchand, *Sir Christopher Wren*, *c*. 1723, ivory medallion, 12.7 × 9.2 cm.

Although Wren is now primarily associated with the field of architecture, and above all with St Paul's Cathedral, his early intellectual passion was natural philosophy, and he was an active and prominent member of the Royal Society.

26 Prudence Cuming,
Rosa Beddington FRS, 1999,
photograph.

 Beddington, who works
on the early development
of mammals, has recently
become a Fellow of the
Royal Society. The
Society's first women
Fellows were elected in
1945, although it had been
made legally possible
for women to become
Fellows in 1922.
Beddington, also an artist,
designed a medal for a
scientific society, a medal
she subsequently won.

answer is a cautious 'yes', provided that we always bear in mind the broad historical shifts to which I have alluded briefly. The rationale for saying this rests on a number of points. First, there is *institutional* continuity. Admittedly, we are only talking about a rather small number of institutions, the ancient universities and a few organizations such as the Royal College of Physicians. But this continuous history is nonetheless important, and the original project of the Royal Society remains alive, even if transformed, in its current activities. Second, there is *intellectual* continuity, which is one of the central concerns of historians of science, medicine and technology. Traditions of scholarship and of practical work were transmitted from generation to generation even if there were revolutionary changes in theories and world-views. Third, there is the deliberate cultivation of a sense of continuity by succeeding generations of practitioners through recording the achievements of forebears and collecting items of historical interest, including portraits.[2] These are

forms of *cultural* continuity. Thus portraiture has long been an important part of intellectual culture: the making and displaying of likenesses are practices through which usable histories are created. In relation to science, medicine and technology, portraits have indeed been used extensively, and they are supercharged with meanings specific to these fields.

Before moving on from issues of terminology, we should note two further points. Ideas work somewhat differently in their various grammatical forms, by evoking distinct connotations, for example. The adjective *scientific* can be applied to a wide range of phenomena and generally implies approval of a measure of intellectual rigour. It therefore tends to be associated with particular types of methods. The abstract noun *science* evokes not only grandeur and power but also a particular type of mastery of the world, basically of the natural world. This does not prevent the term being used with distaste. Either way, it can suggest a vaguely global remit about which it is useful to adopt a measure of scepticism, since whether specific disciplines, broad methods, institutions, practices, theories, attitudes or specific findings are being invoked can be unclear. The second point follows directly: this is also the terrain of metaphor. In recent years, many scholars have explored the rich metaphors through which science, medicine and technology function, and the ways in which these have transformed and been transformed by broad language communities. Hence the manner in which practitioners describe themselves and are described by others is an integral part of complex, changing linguistic practices

WORK

To most people now, work is something done in order to earn money (or it is a necessary chore like housework). I would like to use the word more broadly, since there is no other term for the phenomena I wish to discuss. Work in this context is any sustained activity that requires some measure of knowledge and skill, that is

27 William Faithhorne the Elder, *The true and lively Pourtraicture of Valentine Greatrakes Esq...*, 1666, line engraving, 16.4 × 13.4 cm.

Greatrakes, a controversial figure who was known as 'the stroker', professed to have special healing powers. Although he had no medical training, he did effect some cures, which were claimed (by some) to be miraculous.

undertaken fairly routinely and that is of recognized value, both to the 'worker' and to others. Admittedly, one problem with this definition is that the boundaries between what I am calling work and some 'leisure' activities become rather fluid (illus. 27). So be it. The point about the study of the natural world is that it could not, still cannot, be neatly compartmentalized according to a way of thinking that defines work simply as alienated labour (illus. 28). Such labour does indeed occur in science, medicine and technology, although its nature has changed markedly since 1660 and varies between disciplines and subfields. There can be no doubt that there have been dramatic increases in the division of labour and in degrees of specialization so that much scientific labour is currently done by assistants rather than the 'famous names'.[3] The astronomer William

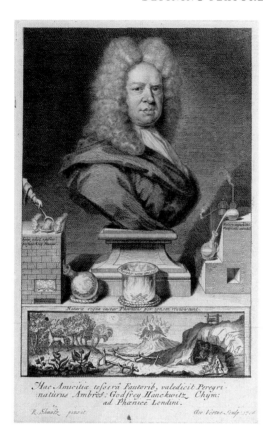

28 George Vertue after R. Shmutz, Line engraving showing Ambrose Godfrey the Elder, 1718, 22.1 × 14.5 cm.

Godfrey worked as an assistant in Robert Boyle's laboratory and was a Fellow of the Royal Society. This print relates to the machine he invented and patented for extinguishing fires.

Herschel, for instance, together with his sister Caroline, spent countless hours polishing the mirrors of the telescopes he constructed, a job that would not now be done by a leading scientist. On the other hand, I suspect that he did not experience the task as alienating – he was his own master, not working for someone else for wages, and he had a special devotion to his astronomical endeavours (illus. 8, 61–3). In this sense, such activities have also been vocations, undertaken because people were called to them, compelled to pursue an intellectual or practical quest, and felt that they were serving some higher cause in doing so. There have been many different ways of framing this cause – God, progress, enlightenment, mastery and so on. People have sought knowledge rather as they

have sought faith or spirituality, although in practice these motives have been mixed in with many others.

Sometimes work takes the form of a recognized occupation – a slot that is named and acknowledged by contemporaries, such as instrument maker or surgeon (illus. 29). Thus bonesetters, astrologers, occulists or herbalists were recognized as such for many centuries; people sought them out as and when needed and paid for their services. These, then, were jobs or occupations by means of which it was possible to earn a living. It was extremely rare to earn one's living directly from the practice of natural history in the eighteenth century, for example. In the present day, there are huge numbers of scientific occupations, so that it would be quite commonplace for 'scientist' to appear as an occupation in a passport, but this is a fairly recent development. So, 'occupation' suggests social recognition, economic reward, some level of specialization and the expenditure of significant amounts of time. While 'profession' carries some of these connotations, it is a quite distinct idea.

In fact, 'profession' is a complex concept because of its associations with expertise on the one hand and with high, recognized standards of behaviour on the other. Sociologists have given a great deal of thought to the way in which 'profession' should be defined. This is an important social issue because professions have, especially over the last two hundred years, acquired large amounts of power over their clients; generally it is a very special kind of power over their most intimate affairs. There is no better example of this than the medical profession. Sociological definitions of professions tend to be based on changes that have taken place over the last century, during which alliances with the state have been consolidated or built, when monopolies of practice have been established, and when the respect and financial rewards offered to professionals have increased markedly. Professions now expect to control entry to their ranks and to regulate their own conduct – that is, they select and discipline their own members. Further, professions develop a distinctive ethos

and sense of the value of their activities, which are typically portrayed as other-directed, not for selfish gain and of benefit to whole communities. Part and parcel of this professional culture is the insistence that lay members recognize and respect their special expertise, which should not be questioned except in the most unusual of circumstances.[4] A patient asking for a second medical opinion is still considered to require special justification precisely because their action suggests a degree of unhappiness with the first opinion. Expertise implies special(ized) knowledge that has been hard won and is not freely available; hence there is a certain mystique attached to it. To perform all these roles, professions are highly organized; they are typically managed by structured institutions, which, because they confer honour and status, are also gatekeepers and policemen. Not everyone can join, and once people have joined, they are expected to conform to the rules and conventions of the group in question.

Professions are not new, although historians agree that the dramatic rise in their power occurred over the nineteenth century. In the cases of medicine and instrument-making, professional organizations such as guilds are very old indeed. The positions that (some of) the professions have been able to acquire would not have been possible without the careful building up by long-established groups, such as medical practitioners, of institutional bases and of a cultural aura around themselves. They were able to do this over a period of centuries precisely because medicine was a recognized occupation, or rather surgery and physic were. Professionalizing strategies require groups, such as those made up of so-called 'quacks', to be carefully excluded.[5] Since the boundaries around a given occupation are frequently fluid and the extent of actual control varies, the profile of a recognized occupation has to be continually managed and refined. It was possible to earn a living doing medicine; this made some doctors extremely rich; hence collective activities that required resources – buildings, collections of paintings, books and silver, for instance – could be undertaken.

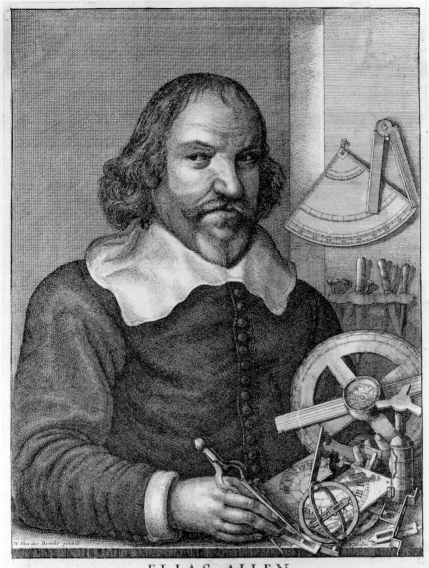

ELIAS ALLEN.

Apud Anglos Cantianus, iuxta **Tunnbridge** natus, Mathematicis
Instrumentis ære incidendis sui temporis Artifex ingeniosissimus.

Londini. prope finem Mensis Martij, Anno a Christo nato 1653, suæque ætatis

29 Wenceslas Hollar after H. van der Borcht, *Elias Allen*, 1666, etching, 25.4 × 18.5 cm.
Allen was a well-known mathematical instrument maker with extensive contacts, in-
cluding in high society. This print is unusual in the prominence it gives to the instruments.

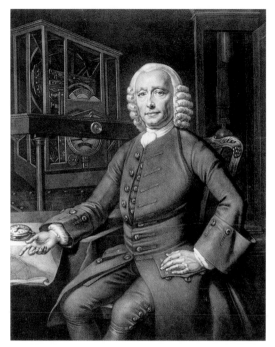

30 Philippe Tassaert
after Thomas King,
John Harrison. . ., 1768,
mezzotint.

Harrison, a clockmaker
of exceptional talent, has
been turned into a
scientific hero by Dava
Sobel's recent book
Longitude, which portrays
him as the victim of a
reactionary scientific
establishment. He was
awarded the Royal
Society's Copley Medal in
1749 and published a
number of pieces on the
longitude problem.

This situation, together with the universal need for health care, enabled first physicians and then surgeons to develop professional structures before it was possible for 'scientists' to do so.

In this sense, the Royal Society of London was not a professional organization. It was not made up of people who earned their living in more or less the same ways. Certainly, medical practitioners were active within it in the early days, but the purpose of the Royal Society was not to promote the interests of an *occupation*. Its founding ethos was altogether broader: to promote learning and the investigation of a wide range of phenomena, only some of which would now come under the headings of science, medicine and technology. This ethos is evident in its early members, such as John Evelyn, who had wide intellectual interests (illus. 1). It was the open pursuit of knowledge according to a gentlemanly model that was desired. 'Gentleman' is a term pertaining to social status, a matter we shall come to shortly.

One implication of my discussion is that science and medicine have had rather different histories, precisely because of the differences between their associated occupations. I shall discuss some of these differences in the next section. The situation with technology is rather more complicated, partly because the term comprises such a huge range of activities (and objects) including industry, instrument-making, surveying, map-making and canal building, just to take examples from the early modern period (illus. 30). Where there were specific commodities or specialized skills for sale, there could be occupations with a technological dimension. However, technology – practical innovation – has often operated independently of 'science' – theorized knowledge of nature – with the precise nature of the relationship varying from case to case.[6] Like science and medicine, technology is an abstract term. In relation to practitioners and their portraits we are considering something altogether more concrete.

SCIENCE, MEDICINE, TECHNOLOGY

We need to consider these terms in a bit more detail, but before doing so I want to return to the people involved since they are the *raison d'être* of the pictures. Their practitioners admittedly provide only one dimension of these domains. One of the most striking features of those societies we think of as most 'advanced' and 'modern' is the presence within them of powerful abstract ideas such as science. These concepts are often treated in a somewhat disembodied way; a focus on the makers of such knowledge puts flesh on them. Looked at from the point of view of people with an ardent curiosity about the natural world, the human body or the functioning of machinery, the situation looks rather different. For practitioners, two issues were of paramount importance: the acquisition of specialized skills and knowledge, and making a living. It is often said that it was only in the nineteenth century that it ceased to be possible for a well-educated person to keep abreast of scientific

developments. Yet, when Newton published his *Principia* in 1687 only a tiny handful of people fully understood the mathematics it contained. By the second half of the seventeenth century, specialist skills and 'training' were required to do serious work in many areas of science, medicine and technology. I put training in inverted commas because it is a modern notion suggesting structured, institutionalized activities, not a particularly apt notion for that time.

We can consider three educational models that were available. Most trades and occupations, including instrument makers and surgeons, recruited new members through an apprenticeship system, which, among other things, helped to regulate the supply of labour. Apprentices typically lived with their masters for several years. Of course they were shown how to do things, but the basic idea was to learn by undertaking tasks of graduated levels of difficulty. Skill and experience went hand in hand.[7] Another model was education at home, with instruction given either by other members of the family or, in the case of the more wealthy, by a tutor. It was possible for an exceptionally sophisticated educational level to be attained by these means, a point that was particularly important for women in periods when more formal schooling was inaccessible. Clearly, much depended on those dispensing home-based education and on the attitudes of other members of the household, but the potential to tailor what was available to the individual was evidently great. The third model of education was a more formal one: some kind of school and then university. For much of the period with which we are concerned, the quality of schooling varied dramatically, and access to universities was limited. Until the early nineteenth century, England only had two universities, Oxford and Cambridge, and neither was fully accessible to those who did not subscribe to the basic tenets of the Church of England. There has been considerable debate about the amount and quality of scientific education offered by these two institutions. Those striving to become physicians were expected to undertake a university degree, although this could be done abroad. In the eighteenth and early nineteenth

centuries, many men of science chose to study in Scotland, a trend that was particularly marked among those who wished to practise medicine.[8]

There is a fourth model we might want to consider, although it hardly involved 'education' in the generally used sense of the term. I am referring to social networks and informal groups, which were also mechanisms through which people could share and refine their knowledge. For example, a local clergyman or doctor with a university education and an interest in the natural world could help and inspire those with whom he came into contact. Such contacts did not have to be direct; elaborate correspondence networks existed in seventeenth-century Europe through which ideas were exchanged, sometimes at the very highest intellectual levels. Prevalent forms of sociability, including dining clubs and coffee houses, were crucial for the dissemination and improvement of knowledge.[9] In some cases, artists were also participants. It may be helpful to think about some of these phenomena in terms of patronage. This term can cover everything from formal help and financial support of the kind often given by monarchs, princes, courts and aristocrats to learned individuals, to more informal encouragement, such as the loan of books, instruments and specimens, letters of introduction and comments on writings. Despite the existence of highly structured careers, especially in the second half of the twentieth century, these informal types of patronage remain of paramount importance, especially for young practitioners. The early career of Dorothy Hodgkin, which was made possible through the help and support of established male scientists, illustrates these points beautifully.[10]

Those without private incomes or generous patrons had to find ways of earning a living. The church or the law were possibilities, and medicine was another. Many medical practitioners were interested in science more generally, and indeed were able to pursue those interests precisely because they had an income to fall back on. There have been many different kinds of medicine practised in this country over the last four centuries, and the incomes they have

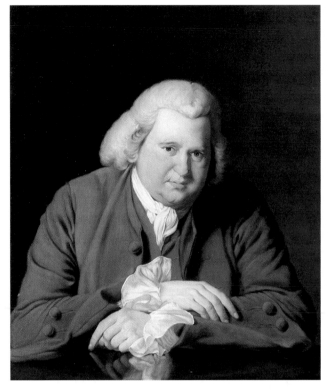

31 Joseph Wright, *Erasmus Darwin*, 1770, oil on canvas, 76 × 63.5 cm.
Darwin and Wright moved in overlapping circles in the Midlands.
It would be impossible to know from this portrait alone that Darwin
was also a medical practitioner.

generated have been equally variable. Richard Mead and William
Hunter were special cases, in that they were able to generate signifi-
cant fortunes, live well and amass important collections.[11] There
have been medical practitioners in many periods who barely
scraped a living. Those whose appearance was given permanent
expression were in these respects not necessarily typical of their
chosen occupations. Hence it is always important to ask why a given
person was depicted at all. An apt example here is Erasmus Darwin,
grandfather of Charles, an able and respected medical man and
part of the well-known Lunar Society, an informal group of natural

philosophers who met from the mid-1760s until the end of the eighteenth century to discuss matters of shared interest (illus. 31). The group included Darwin's close friend James Watt, who was able to make considerable amounts of money from his expertise, which could be described in modern parlance as both scientific and technological. Watt was an engineer, inventor and entrepreneur (illus. 32). Darwin's main claim to fame, however, was as a writer who composed lengthy poetic works on broadly scientific subjects.

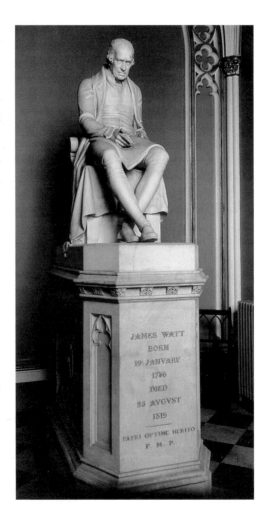

32 Sir Francis Chantrey, *James Watt*, 1841, funerary statue. St Mary's Church, Handsworth, Birmingham.

This version of Chantrey's statue is located near the heart of Watt's manufacturing activities in England. Other versions are in Glasgow, Greenock and St Paul's Cathedral, London (originally in Westminster Abbey).

In his portraits, he is usually depicted as a writer, holding a pen and without medical accoutrements.[12] Although there were a number of renowned writers with medical backgrounds, such as John Arbuthnot the wit and Tobias Smollett the novelist, Darwin kept practising medicine and maintained his intellectual interests in science throughout his life.

As an occupation, then, medicine took many different forms, some of which were considerably more lucrative and intellectually stimulating than others. Although we can speak of 'medicine' in the abstract, it is clear that this skates over huge variations, variations that were crucial to those on the ground. Institutional affiliation, the character of the clientele, the geographical location of the practice and the type of medicine practised were among the most crucial variables. Medicine was a complex idea, and it could be used to refer to certain kinds of knowledge – those that concerned the human body in health and disease. What the term does not convey are the textures of practitioners' lives.

Three aspects of these are particularly relevant to portraiture: participation in existing institutions, work in founding and running new ones, and widely recognized achievements, such as Edward Jenner's 'discovery' of vaccination.[13] Existing institutions not only commissioned portraits of those who were active within them; they also received gifts and legacies that affirmed the status of their members. For instance, Richard Mead gave a bust of William Harvey, an illustrious forebear, to the Royal College of Physicians, an institution within which he was extremely active. In such cases, the status of the institution itself, the company that portraits kept and the esteem given to individual members were mutually reinforcing.[14] A particularly good example of how this worked may be found in the Royal College of Surgeons, owner of the famous portrait of John Hunter by Sir Joshua Reynolds. It hangs in pride of place; indeed, it features in other paintings associated with the College. Hunter's museum is still on display in the building, and he has long been accorded the status of pioneering innovator in the

33 The Council Chamber of the Royal College of Surgeons of England, Lincoln's
Inn Fields, London, 1999.
 John Hunter is an important figure in the history of the Royal College of Surgeons.
His portrait by Reynolds, painted in 1785/6, is central to stories of its past, which
continue to have currency in the present.

history of surgery precisely because he was also a distinguished man
of science (illus. 33, 69). Hunter's pupils worked hard to give him this
pre-eminence, which reflected well on the college, after his death.
The portrait was made into many prints, and a statue of Hunter was
also based on it.[15]

 Medical practitioners have also been closely involved in the
foundation of new institutions such as voluntary hospitals since the
mid-eighteenth century. We have already noted the involvement
of Richard Mead in the London Foundling Hospital, which had a
high profile within metropolitan culture; Mead is said to have
been an advisor to Thomas Guy, the benefactor of Guy's Hospital
in London. Especially in the provinces, this was a route to local
renown and also to commemoration in the form of portraits, busts
or statues. For example, Griffith Rowlands, a provincial surgeon,

34 A. R. Burt after Henry
Wyatt, *Griffith Rowlands
Esqr. Surgeon*, stipple
engraving, 24.8 × 18.3 cm.
Griffith Rowlands
was not a famous doctor
but an active local
practitioner. Nonetheless,
he was portrayed in a
print.

was the originator of the Ladies Benevolent Institution in Chester
in 1798 (illus. 34).

We are most familiar with the third form of achievement:
making an innovation of some kind, such as the discovery of some-
thing. Such activities are easy to tag, and for many fields they have
become the main point at which specialists and the public interact.
Examples include attaching a scientist's name to a natural object,
a law or a form of measurement. For instance, many species pay
homage in their names to Charles Darwin. In the terminology of
electricity, we commemorate James Watt, Alessandro Volta, André-
Marie Ampère and Georg Ohm. The high-profile and much-coveted
Nobel prizes, first awarded in 1901, reinforce the emphasis on the
heroic attainments of individuals in their association of scientific
innovation with specific individuals. This is perhaps one of the
features that the three domains of science, medicine and technology
share most obviously. Their public faces, which overlap in the late
twentieth century, have come to be strongly associated with progress.
The stages of supposedly continuous improvement are marked by

milestones conveniently associated with an individual or a limited number of people.[16] This situation is not accidental, but has developed in the context of a cult of individual genius. Such a cult was evident following the death of Newton in 1727, and over the next century a number of towering figures emerged, such as Watt and Jenner, who seemed worthy of special treatment. The Victorian period saw a number of comparable figures – Michael Faraday and Charles Darwin, for example (illus. 20, 35). The cult of the great

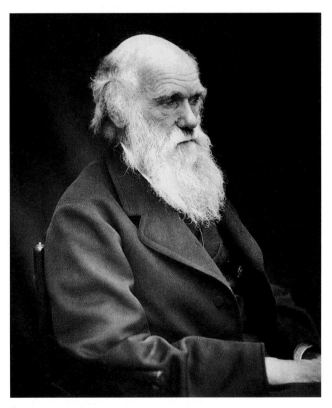

35 Leonard Darwin, *Charles Darwin*, 1870s (?), Woodbury print.
 Leonard Darwin, who was an army officer, politician and eugenicist as well as a keen photographer, was Charles's son. He greatly admired his father and saw himself as continuing his work, as his publications make clear. A prominent figure in Victorian Britain, Charles was frequently depicted in many media.

36 Kilburn and Lenthall, *Florence Nightingale,* *c.* 1854, *carte de visite,* 8.7 × 5.4 cm.
Florence Nightingale became a formidable force in British society after her return from the Crimea in 1856. In this *carte de visite* she is a demure young woman.

scientist is still alive and well in the twentieth century, as is evident from the way in which Stephen Hawking is treated. The celebration of individual achievement requires appropriate forms of cultural expression that can be widely disseminated. The seemingly inexhaustible enthusiasm for biography would be one example. The genre has a certain flexibility, especially when seen in the context of cognate forms such as the obituary. Portraiture, however, is even more flexible in that images can be produced in a huge variety of forms, materials and sizes and for diverse markets. Since they can be taken in at a glance, they readily become both icons and symbols.

Abstract domains that are difficult to grasp become more accessible when we give them human form; this is one of the cultural operations that portraits perform. Nonetheless, science, technology and medicine as ideas possess a certain aura that is qualitatively

different from the heroism of their practitioners. Precisely because of this aura, they need constantly to be subjected to constructive critical scrutiny. Let me give a small, but nonetheless revealing, example. We can give the term *medicine* two broadly different inflections with respect to the activities it includes. According to the first, 'medicine' is primarily medical science, or bio-medicine as it is sometimes called in its twentieth-century guise. In this definition, research is given high status, and the main group of practitioners to be considered are those who are medically qualified or who have doctorates (or their equivalent) in a cognate field. According to the second inflection, 'medicine' includes anything to do with health care and its delivery, which embraces a far wider range of activities and occupations. Evidently, each embodies distinct assumptions about intellectual, gender and social hierarchies. The most obvious instance involves nursing and midwifery, which would count as medicine according to the second definition but not the first. It is not that only one definition of medicine is correct, but that such definitions reveal differing perspectives. Nor can we turn to the past for clarification. In some periods, the term *nurse* could only be used to describe an extremely heterogeneous group that interacted infrequently with medical practitioners as the phrase is generally used and had received little or no specialized training. The person most closely associated with changing the status of nursing, Florence Nightingale, had, to say the least, extremely fraught relations with doctors and built her vision of nursing on clear distinctions between the two occupational roles (illus. 36).[17]

WORK AND IDENTITY

The theme of this chapter is boundaries, boundaries of various kinds. There are boundaries between kinds of knowledge and types of practice. These mark out fields and disciplines and distinguish sound from unsound methods and knowledge. There are also boundaries between groups, occupations and professions. Some-

37 William Wyon, Obverse of the Geological Society of London's medal portrait of William Wollaston, c. 1831, d: 4.5 cm.

Wollaston was a versatile man whose interests included medicine, chemistry, mineralogy and physiology. His generous donation to the Geological Society in 1828 became the Wollaston Fund, out of which this medal is financed. Wyon was an exceptionally fine medal maker. In this instance, the head was modelled by Sir Frances Chantrey.

times, they are reinforced, at other times they are challenged or ignored. In many periods, the boundaries we have internalized so thoroughly simply did not exist. In relation to science, medicine and technology between 1660 and 1800, the maps of knowledge, practices and occupations are profoundly alien to the late twentieth-century mind. Assumptions about class and the production of natural knowledge would be an example of how dramatically boundaries have shifted. I have already mentioned the interest of the early Royal Society in gentlemanly knowledge.[18] In the early nineteenth century, new organizations such as the Geological Society of London, founded in 1807, embodied assumptions about the relationship between social status and the generation of geological knowledge that privileged the gentleman scholar over the practical man who earned his own living (illus. 37–41). It would be wrong to assume that gentlemen scientists were not dedicated and expert, although degrees of intellectual sophistication clearly varied.[19] The point is that when there were few career structures for the scientifically gifted and the precise social role of natural

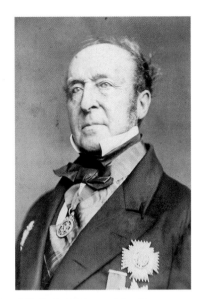

38–41 Various photographers, *Cartes de visite* of Sir Roderick Impey Murchison.

Murchison, who was awarded, among other scientific prizes, the Wollaston medal, was an influential 'gentlemanly geologist'. He was knighted in 1846 and became a prominent public figure. These *cartes de visite* show the range of ways in which such a person could be depicted. The obvious studio backdrops suggest how conventionalized such formats had become.

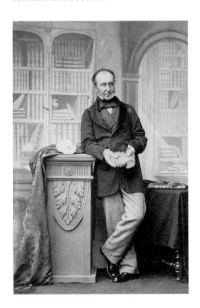

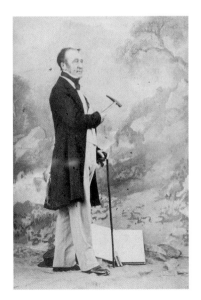

knowledge was under intense public discussion, the social status of 'scientists' was bound to be contested. Furthermore, there were a number of different models of scientific activity available, each of which carried its own connotations. Many able practitioners were skilled artisans or tradesmen, and their social position and influence were necessarily different from those of a university-educated and financially independent gentleman. Hence class boundaries were inevitably caught up in the changing position of men of science.

Delineating clear boundaries was especially crucial in areas where there was direct economic competition. It was for just this reason that quackery was such an emotive subject for those who considered themselves legitimate medical practitioners. Many historians have insisted on the importance of the medical market-place, especially in the periods before effective, state-based regulation (illus. 42).[20] The phrase 'medical marketplace' is designed to draw attention to the wide range of choices patients had when it came to types of therapy and their cost, to medical eclecticism on the part of both practitioners and patients, and to the wide range of market niches available to healers. We should remember that this

42 Bath Oliver biscuit.
 The head of Dr William Oliver, who practised medicine in Bath during the town's 18th-century heyday, can just be seen in the middle of this biscuit.

is not only a historical phenomenon; patient choice continues to be an extremely controversial area with the rise of alternative or complementary therapies and of health-related occupations, which may well regulate themselves but which are poorly understood by the general public. I would include psychotherapy and counselling in this last group. It is also vital to remember that there are no objective criteria for the attribution 'quack'. The more legally enforceable criteria exist, the more tempting it becomes to imagine that there are standard, objective means of judging the quality of medical practice. Historical evidence does not bear this out. 'Quack' has largely been a label applied to those who are threatening in some way; it basically means 'doing things or making claims that I/we do not like'. Attributions of quackery depend upon the vantage point of the accuser.

The example of quackery illustrates an important general point about occupational labels. They serve to define who is 'in' and who is 'out'. They differentiate a collective self from others, and in so doing they define the respective status of various activities. While there is a degree of contingency in these matters, they generally involve a limited number of issues such as gender, the relationship between manual and intellectual work, and the extent of public (including government) recognition. None of these issues are historical constants, and, as I have already indicated, broad shifts in the economy and the organization of work play a part. Nonetheless, it remains the case that jobs done largely by women and with a high manual component tend to be less esteemed than those undertaken mostly by men with a highly specialized and/or academic component.[21]

So far I have not placed particular emphasis on what can be called the political aspects of jobs related to science, medicine and technology. The term *political* needs precise definition in this context. Its most obvious meaning is in relation to government – many scientists have worked for governments in one capacity or another, and in this respect their positions are unavoidably controversial. Everyone

reading this book will be familiar both with contemporary conflicts over science policy and scientific advice given by government departments, and with examples from earlier in the century of regimes misusing medical and scientific activities for their own ends, in eugenics, for example. Intricate relationships between the state and natural knowledge are hardly new, and many of the individuals depicted in *Defining Features* were, in one way or another, servants of governments. De la Beche, Faraday and Murchison (illus. 20, 38–41, 86–8) are obvious examples from the nineteenth century.[22]

But there are also looser ways in which politics are at issue. It may be easier to present them in terms of Victor Frankenstein, the eponymous hero of Mary Shelley's novel, first published in 1818. The point about Frankenstein is emphatically not that he describes the way in which practitioners have actually functioned at any historical period, but that he managed to capture the public imagination so completely and that he continues to do so – witness the phrase 'Frankenstein foods'. Thus I infer that Shelley was able to give fictional form to deep-seated concerns about how knowledge of the natural world is generated and used, and I would call these concerns 'political' in that they pertain to the exercise of power.[23] While there have been huge shifts in the forms such concerns have taken over the period covered by this book, certain themes persist. First, there is the anxiety that the drive to uncover really potent knowledge is experienced by those who are psychologically unusual in some way. Both they and their knowledge, then, are unhealthy and potentially dangerous. Second, it follows that such people are likely to be set apart from others and that their knowledge may be difficult to control once it has been, as it were, unleashed. Third, it is suspected that uncommon intellectual attainment may be a form of excessive pride. Hubris involves human beings taking a role that is not rightfully theirs. I am not saying that such fears are groundless or that they are justified. I am only pointing out that this myth has a special grip on us, that it was not new in Shelley's time and that it

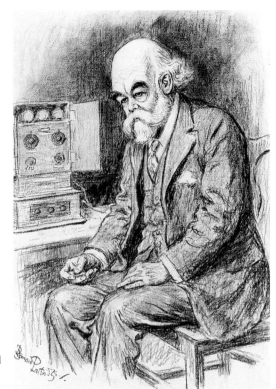

43 Sir Bernard Partridge, *Sir Oliver Joseph Lodge*, 1926, black chalk, 36.2 × 25.7 cm.

Despite leaving school at fourteen, Lodge enjoyed a successful career as a physicist. He was actively involved in psychical research, studying some famous mediums of his time. He was also the first principal of the University of Birmingham.

places a peculiar set of burdens on those who do wish to reveal nature's secrets. Science and power are intertwined (illus. 43).

The currency of words like *boffin*, *nerd* and *egg-head*, along with many other phenomena, reveal that these concerns are still alive; portraiture has played a special yet complex role in relation to them. On the one hand, many portraits of practitioners stress that they are just ordinary people who also happen to make and possess special kinds of knowledge. Sometimes, their respectability is also emphasized. On the other hand, a limited number of figures are portrayed precisely because they are absolutely exceptional, geniuses of a kind the majority can only marvel at. The most familiar example of this is Albert Einstein, of whom a particular image has become synonymous with the 'wild genius' (illus. 44; compare illus. 45). And the

44 Roy Anderson, Cover of *Time* magazine showing Albert Einstein, 19 February 1979.

That this was the second *Time* cover to feature Einstein reveals just how much fame he acquired. His face became known through the mass media, and he became closely associated with the idea of scientific genius in general and with the atomic bomb in particular.

45 H. Channing Stephens, *Havelock Ellis*, oil on board, 17.6 × 12.5 cm.

Havelock Ellis is best known as a pioneer sexologist, writer and social thinker. Although he studied medicine in London, he scarcely practised at all. An unconventional man by any standards, he appears in this portrait as a sage outside ordinary time.

genius is seen as a kindred spirit to the madman. Both the 'ordinary' and the 'exceptional' types are associated with important visual tropes. As occupations become more structured, it is necessary to believe in the general reliability of those who carry them out. Yet the cultivation of special people reaffirms the value of the enterprise as a whole as well as a faith in the power of human beings to control their own destiny through knowledge.

BACK TO PORTRAITURE

Portraits are a special class of object, but they should not be seen in isolation. I have already mentioned the intricate connections between biography and portraiture. If likenesses of practitioners were valued, so were other remnants of them, if I can put it that way. Locks of hair, items in daily use, letters and objects associated with their work have all been cherished as tokens, reminders of outstanding individuals. On the back of the miniature of Robert Willan is a delicate pattern of hair and seed pearls (illus. 17). A lock of William Hunter's hair was carefully preserved and is now in the collections of the Royal College of Surgeons (illus. 46). It was common to keep the instruments, snuff boxes, cuff-links and so on belonging to high achievers. Such people (so far mostly men), or rather representations of them, readily gathered extra layers of significance, both during their lifetimes and after their deaths. A tangible token of a friendship with an outstanding person con-stantly reminded its possessor of the esteemed person, reinforced their ties and elevated the owner. From the point of view of a wider public, relics, including portraits, were objects of emulation; their display affirmed the value of particular activities. The very notion of emulation has an archaic ring to it, yet for centuries it was a vibrant idea. To be in the presence of likenesses of outstanding people was deemed to be inspiring.

It was not necessary for there to be specific accoutrements in portraits for these effects to work. Provided you knew, or thought

46 Lock of William Hunter's hair.
 Science and medicine have produced their own relics; this is the context in which we
should see this lock of Hunter's hair.

you knew, who you were looking at, the face and sometimes the
body could be quite sufficient. This is because most people subscribe,
and have done so for centuries, to assumptions about the visibility of
character in the face. This simply had to be sufficient if the artist
and/or sitter rejected the idea of including further signs of the
latter's work. It could be that there were no suitable or acceptable
objects to hand. Where there were accoutrements, they seem to
me to fall into one of four categories. They either provide visual
interest, or follow established conventions, or convey information
thought valuable to viewers, or act as symbols. Tom Phillips's
portrait of Peter Goddard, a distinguished mathematician who is
the Master of St John's College, Cambridge, would come into the
first category (illus. 47). Items in the painting that seem merely to be
patches of colour or 'background' offer visual interest of a quite
specific kind associated with the sitter, his Cambridge location and
the nature of his work. For instance, much of the background is
covered by a pattern that refers to Dirac's equation, an aspect of
mathematics on which Goddard has worked. Paul Dirac, one of the
major mathematical minds of the twentieth century, spent much of
his life in Cambridge and was also a member of St John's College
(illus. 21). Thomas Eakins similarly provided visual interest in his

47 Tom Phillips RA, *Professor Peter Goddard*, 1996, oil on canvas, 61 × 91.4 cm.
Goddard, Professor of Theoretical Physics at the University of Cambridge, became
Master of St John's College, Cambridge in 1994 at the young age of 49. All Masters are
painted during their time in office.

48 Tricia Malley, Photograph of Dr Lesley J. Yellowlees, 1997.
This stunning image is discussed at the beginning of Chapter IV.

49 Thomas Eakins, *Professor Henry A. Rowland*, 1897, oil on canvas in a carved chestnut-wood frame, 203.8 × 137.2 cm.

Eakins studied anatomy in Paris and was friendly with a number of scientists and doctors; his work attests to his deep interest in matters scientific. Rowland was a leading physicist at the Johns Hopkins University in Baltimore. The picture's frame is covered with carved circles, lines, mathematical equations and crudely drawn diagrams.

fabulous portrait of Professor Henry A. Rowland with its extraordinary frame (illus. 49).[24] The use of objects such as a bust of Hippocrates or a caduceus would be good examples of conventionalized accoutrements. A caduceus would be equally apt for any medical practitioner, so its inclusion has to be seen in terms of established patterns for accoutrements. Objects could be included for the sake of information thought useful to viewers, as James Northcote testified in relation to one of his paintings of Edward Jenner. As we shall see in Chapter III, in the case of Jenner anything to do with cows could act as a reminder to viewers of his special achievement. Cows also became symbols, although as such they were inherently limited.

A particularly interesting example of the object as symbol is the molecular model. It could be said that such items were included for the sake of information, but they seem to be more culturally dense than that. We could consider, for example, how familiar people have become with the notion of the double helix, so that it now symbolizes the capacity to map genes. Molecular models suggest human beings' capacity to get inside the structure of matter using a range of extremely sophisticated techniques. Since most viewers could not tell one molecule from another or appreciate that there are many different kinds of models, the model itself functions as a symbol.

I want to resist any easy generalizations about scientific, medical and technological portraiture and to re-affirm the range of cultural business that everyone undertakes. All sitters present their own visual possibilities, and how these are taken up will depend on their relationships with artists, the medium and format chosen, the commissioning process and so on. It is precisely because each case needs to be considered on its own terms that I turn to more detailed examples in the next chapter. I have indicated that distinctive kinds of historically specific heroism were forged for a limited number of individuals. These were mostly men, and in relation to science and cognate fields, heroism almost automatically suggests masculinity. Yet there were scientific heroines as well. We therefore need to probe these questions of gender and heroism a little more closely (illus. 48).

III

GENDER AND SCIENTIFIC HEROISM

OUR HERO

James Dr Jenner Sarah Blossom

50 Jenner bookmark, 5 × 21 cm.

Published by the Jenner Appeal Trust, this bookmark is available at the Jenner Museum. Many galleries and museums use such items to promote themselves and their values.

Consider the bookmark produced by the Jenner Museum, located in Berkeley, Gloucestershire, where Edward Jenner lived and worked (illus. 50, 51). He is buried in the local church a few steps away, and the Museum is in his own house. The bookmark is a frieze of the significant players in the discovery of vaccination, including Blossom the cow. An oil painting of Blossom stands over the fireplace in the main room of the Museum, which owns at least three sets of her horns. Cows too can be heroes and generate relics. An arrow points to Jenner himself, with the explanatory words 'our hero'. The image of Jenner on the bookmark is hardly a portrait in the strict sense, but it provides valuable insights into the kinds of heroism found among practitioners of science, medicine and technology.

Edward Jenner was born in 1749 into an educated and fairly well-off family. A number of family members were clergymen, which implies a certain level of intellectual sophistication. For our purposes, three aspects of his early life deserve attention. The first is his interest in natural history, which was sustained throughout his life. Natural history provided access to ideas and methods which were loosely scientific as well as a strong point of common interest between Jenner and John Hunter, his teacher and mentor, who became a figure of considerable importance in his pupil's life. Second, Jenner's training began with an apprenticeship to a local surgeon. Apprenticeship, as we have seen, is a very particular form of training; a long way from being abstract and bookish, it empha-sizes practice, not medical theory. Surgery was based on manual skills, and although some surgeons were extremely well educated, it remained in this period an assembly of practical skills that depended on a good working knowledge of the body. Third, Jenner completed

51 Edward Jenner's Study, now part of the Jenner Museum, Berkeley, Gloucestershire.
The Jenner Museum seeks to educate the public about Jenner and his achievements;
it also presents material on immunology and the history of smallpox.

his medical education in London, where he attended private lectures and demonstrations, such as those given by the Scottish brothers John Hunter and his brother William, by George Fordyce, and by Thomas Denman and William Osborn. He also gained hospital experience and mixed with cosmopolitan men of science such as Sir Joseph Banks.[1]

Jenner's early life was thus quite varied, and it included being closely involved with people who were original and influential. He never became a metropolitan man, although he did extensive business in the capital and was a Fellow of the Royal Society. What models of achievement were then current, given that Jenner was a surgeon by training? It is hardly a secret that the reputation of surgeons was rather low in this period. In the popular mind, surgery was associated with butchering and butchery, and also with grave-robbing, since there was a dearth of bodies for anatomical purposes.

It was also perceived as cruel and crude, its practitioners as coarse. It is important to recognize such stereotypes for what they were, but they nonetheless had a bearing on both the value accorded to certain occupations and the forms of public celebration that were possible. Over the eighteenth century, only a limited number of forms of heroism were available to medical practitioners. The example of Newton scarcely applied to them; alternatives were provided by doctors who achieved eminence by other means, such as writing, and those who were feted as important and influential practitioners with high-status clients, possibly royal connections and impressive incomes. In the first half of the eighteenth century, most of these were in fact *physicians*. The example of Richard Mead has already been mentioned; Mead was part of a special lineage of physicians with lucrative practices and royal connections of which there were only a few members.[2]

Surgeons were a rather different case, and I would suggest that the first key figure here was William Hunter rather than his younger brother John, whose influence was most marked at the end of the eighteenth and beginning of the nineteenth centuries. William Hunter started out as a surgeon, and his importance derives from the remarkable economic, social and cultural success he enjoyed. Since he became a well-known figure in London, moving in court and aristocratic as well as in literary and artistic circles, William Hunter could be seen as a figure worth emulating. Like Mead, he was an enthusiastic and knowledgeable collector, as well as an expert anatomist. His dual interest in art and medicine was re-inforced by his appointment as the first Professor of Anatomy on the foundation of the Royal Academy of Arts in 1768. Hunter was friendly with such men as Sir Joshua Reynolds, the Academy's first President, who was to produce a memorable portrait of his brother John. It is perhaps significant that William was on easy terms with his upper-class clients, whereas John had a much less engaging manner.[3] Yet it would, I think, be fair to say that William was not, in the sense that Edward Jenner became, a hero. Jenner

52 Lucien Le Vieux, *Captain James Cook*, 1790, marble bust, h: 58.4 cm.

Cook is a special kind of hero in that while his achievements in navigation and exploration touched on many aspects of 'science', he could not easily be dubbed a 'scientist'. He was awarded the Royal Society's Copley Medal and worked closely with some distinguished naturalists.

came into contact with successful men of science in the metropolis, but while he was a student in London none of them offered a strong model of heroism (although it may be worth considering the extent to which figures such as Captain James Cook and Sir Joseph Banks, who had travelled extensively in the service of science, were worthy of emulation) (illus. 52). We may conclude that this was a period in which models of intellectual, and especially scientific and medical, achievement were both limited and labile. One clue as to how they changed may be found in the word *our* on the bookmark.

To whom does 'our' refer? The most limited way of reading it would be as a reference to those who produced the bookmark and those who would use it. But 'our' implies a collectivity of some kind, so what would join together makers and users of such a bookmark in a meaningful way? The only plausible interpretation, borne

out by many other materials having to do with Jenner, is that he benefited humanity as a whole. We, the human race, since the late eighteenth century, have found in Jenner a hero who is 'ours' because his work is of universal value. Jenner's contemporaries and followers certainly thought of it in that way, and they were quick to spread the message. Two hundred years later, Jenner's achievement can be given another layer of significance. Smallpox is the only disease ever to have been eradicated through human action, although there are supplies stored in laboratories. Thus Jenner's vaccination technique has a special status, not just by virtue of being unique but because it bears testimony to *effective* medical action (illus. 53).[4]

Another way of thinking about 'our hero' is in terms of national achievement. To return to Sir Isaac Newton, there is absolutely no doubt that by the time of his death in 1727 there was considerable national pride in a man whose intellect was so evidently gargantuan. Newton was important, and to be celebrated for his sheer brain-power, although we know that this public image had been carefully

53 Plastic keyring containing a postage stamp designed by Peter Brookes, 1999.
 This stamp was issued twice in 1999. Although it is not strictly accurate, in that Edward Jenner did not use Friesian cows, the image cleverly conveys an 18th-century 'look'. Keyrings containing the stamp can be purchased at the Jenner Museum. For a contemporary silhouette of Jenner, see illus. 54.

cultivated by his coterie. The precise form of his achievements was relevant to his status as a *national* hero: for instance, he was anti-Cartesian and Protestant.[5] We might want to compare Newton with James Watt, who also became a major national hero. Watt was certainly admired because he was clever, but he was also an ingenious inventor and a successful entrepreneur who was seen to have given Britain considerable economic power. The unprecedented power that steam engines produced acted as a figure for Watt's intellectual, and Britain's economic, potency. It fired the imagination of his contemporaries, including Sir Walter Scott. One point about Watt that sets him apart from Newton but allies him with Jenner is the general human benefit that seemed to flow directly from his science. The first place where those benefits were felt was his own country.[6]

Watt's skills were in science and engineering, whereas Jenner's were in medicine. These were and are very different domains. Although Watt was a brilliant innovator, he was building on established technological traditions. Prior to Jenner, medicine had had very few therapeutic successes of a significant order. Furthermore, smallpox was a special disease, especially lethal to the young and frequently leaving its victims dreadfully disfigured. To tame a disease of this kind was an achievement indeed. The point is even more significant when we consider the limited range of operations that surgeons undertook. They could cut things off and deal with wounds; internal surgery was extremely limited. In other words, surgery – Jenner's occupation – was reactive rather than preventative.

Let us stay for a moment with the idea of preventative medicine. This was one of the main enthusiasms of eighteenth-century practitioners, including physicians, but what they mainly offered in this connection was advice about lifestyle. Innumerable medical advice books aimed at various markets were published during the eighteenth century. Little of this was new; indeed it drew on centuries of interest in hygiene. Although this branch of medicine had a noble lineage going back to Hippocrates, it was not thought of as par-

HINTS

Designed to promote

Beneficence

Temperance

& Medical Science

Vol. 3.

By John Coakley Lettsom M.&LLD. &c.

Dr Jenner.

London.

J. Mawman.

1801.

Printed by J. Nichols Red Lion Passage Fleet Street.

54 J. Miers, Title page with aquatint silhouette of Edward Jenner, from J. C. Lettsom, *Hints Designed to Promote Beneficence, Temperance, and Medical Science* (1801).

Lettsom published a great deal and was often embroiled in controversy. Having thrown himself into the defence of Jenner's ideas, he gave their association tangible form by using Jenner's portrait on the title page of one of his own books.

ticularly modern, and it certainly did not require much expertise, although there was a certain pretence that it did.[7] In developing a new technique, vaccination, that made inoculation easier and safer, Jenner was doing something special. By the same token, inoculation and vaccination were controversial; they involved a particular kind of meddling, giving people a disease in mild form to prevent something far worse. In practice, neither was a particularly intricate procedure, and there were fierce disputes about who should and should not be allowed to practise them. Disputes arose precisely because there was a medical marketplace in which it was virtually impossible to control all those who set up practice, as many inoculators

55 James Northcote, *Edward Jenner*, 1802, oil on canvas, 109.2 × 86.4 cm.

Northcote's first portrait of Jenner bears eloquent testimony to the importance of medical networks for both the public relations side of medicine and the commissioning of portraits. It was commissioned by medical admirers in Plymouth, who chose an artist born in their area.

did, running special houses where clients could go and stay during their treatment.[8]

Jenner presented the possibility of a new type of prevention, and he performed one further act that is central to the type of hero he became. He did not keep his discovery a secret or seek to make personal financial gain from it. In this sense, he was visibly altruistic. To fully understand the significance of his attitudes, we need to return to the spectre of quackery. Quacks were thought to be motivated by greed, and one of the most significant manifestations of their desire for wealth was the sale of remedies. If, as was invariably the case, the recipe for these was secret, then establishment practitioners were particularly infuriated. The combination of secrecy and financial gain flew in the face of a particular model of scientific and medical activity that was already being forged in the seventeenth century. This ideal suggested that knowledge should be shared and evaluated by educated, impartial gentlemen. Ideals and realities are quite distinct, of course, but such ideals were, and continued to be, important, not least because they could be used to do further cultural business, such as the condemning of quacks. Jenner, then, played by these rules, and he was rewarded with substantial grants from Parliament.[9] He also gained many ardent followers who promoted the Jennerian cause (illus. 54, 55).

By the early nineteenth century, the scientific or medical hero was working to benefit humanity as a whole; he eschewed personal gain and lived a respectable life, all of which made him a worthy object of emulation. So far, I have assumed that such heroes were men; we now need to consider the question of gender and scientific heroism.

SILENT GENDER

It is indeed the case that the overwhelming majority of heroes in these fields have been and continue to be men. A quick glance at lists of Nobel prizewinners confirms the point for the twentieth century,

although I am not suggesting that this is an adequate definition of heroism. The point is simply that in terms of formally recognized, exceptional success – one major determinant of heroism – women are still in a tiny minority. The explanations for this situation vary to some degree with the historical period under consideration. Thus the situation at times when women had little or no access to education or training must be interpreted in a different way from the late twentieth century, when women can become scientists, engineers and doctors relatively easily yet still constitute a minuscule proportion of 'great scientists'. However, it must be admitted that there are also deeply ingrained attitudes that run across historical periods: associations between masculinity and intellectual prowess, for example.[10]

It might be thought pointless even to raise questions about gender and science in Jenner's time, given the general situation of women then. However, this would be too simplistic and literal-minded. Precisely because much education occurred by informal means and a great deal of scientific and medical work happened in practitioners' homes, women had a wider range of possibilities than their absence from more formal structures suggests. Furthermore, there were at least two great female scientific figures among Jenner's contemporaries: Caroline Herschel and Mary Somerville. Before turning to them I want to suggest the importance of gender by following a somewhat different line of argument, one that can be summed up by the phrase 'silent gender'.

There has been a dramatic growth of interest in gender in recent decades. Most scholars use 'gender' to draw attention to the ways in which societies create and manage the differences between the sexes. Although there has been fierce discussion about the relationships between biological and cultural differences, and indeed about whether these are themselves meaningful categories, there is a widely held view that gender differences are of major importance in any society because they bear on so many issues. I do not want to get caught up in what seem to me to be rather sterile debates about

whether women's brains differ from men's and if so in what ways. Historians have the chance to examine both the arguments that are made at any given time about men and women in relation to science, medicine and technology and the actual activities and achievements of specific individuals. I have studied no historical situation where gender was not an issue, but the forms it takes are varied and subtle.

The subtleties of how gender is constructed and responded to are worth insisting on. There have certainly been times, and the second half of the nineteenth century was one of them, when women made explicit demands – for example, for entry to medical schools – that were ardently opposed in some quarters. The result was that both sides had to be direct (and persuasive) in making arguments that supported their cause. In such cases, polarized, crude and sometimes quite vicious claims were made, for instance about the unsuitability of women for intellectual work.[11] Today, they sound quite ludicrous. However, as a cultural force, gender often works in more insidious, less explicit ways. Indeed, sometimes it is silent, but it is still there.

In Jenner's time, the vast majority of those active in science, medicine and technology were men. The only significant opportunities for defining themselves in contrast to women derived from midwifery and quackery, which directly affected only small numbers of practitioners, if we take the three domains together. Nonetheless, it was a time when professional and occupational identities were being transformed. This is evident, for example, in the growth of institutions, in the increase in both paid and government-related employment and in the delineation of distinct fields such as biology and geology. These were partly processes of specialization. They necessarily involved the careful management of professional identities, both for individuals and for groups. Any intellectual demarcation has to be internalized by practitioners; otherwise it will not be of any significance. Additionally, since such demarcations are arbitrary, they require constant maintenance to be

convincing. Part of this maintenance involves traits such as class and gender. The fact of formally recognized practitioners being men is significant, and I would suggest that the manner in which their identities were constructed simply took for granted that (a certain kind of) masculinity would be central to it. But this was a silent assumption on the whole because there was no special need to articulate it in confrontational terms.

Let us remember that paid jobs for scientific intellectuals were in short supply in the early nineteenth century. Many of the most distinguished practitioners, such as Sir Charles Lyell, the geologist friend of Darwin, did not need paid employment. Lyell was a gentleman who had studied law. The early years of the British Association for the Advancement of Science, founded in 1831 as a 'democratic' organization to bring science to the public, nonetheless testify to the continued importance not just of gentlemen but of aristocratic patronage for scientific activities.[12] Such associations were not unproblematic in a country intensely preoccupied with questions such as the extension of the franchise and the nature of working-class radicalism. The claims to which I have alluded concerning the universal benefits of science certainly did not go unchallenged. For example, those who held conservative religious and political views were prone to equating science with materialism – that is, with a world-view thought to pose a very real threat to the existing social order. In retrospect, this is rather ironic, given that so many men of science of the late eighteenth and early nineteenth centuries were ardent Christians; often a religious motivation was a powerful force underlying their intellectual commitments. Yet the sense of science as a threat to cherished traditional values, which has never gone away, should not be lost sight of because it set a tone to which practitioners inevitably responded.[13]

A further factor had to be taken into account in the construction of scientific identity. In Chapter I, I mentioned the anxiety that men who were too intellectual became inward-looking and self-absorbed – that is, melancholic. Despite the development of many more insti-

tutions, especially in the nineteenth century, much scientific and medical work was carried out in domestic settings. This situation reinforced the potential for seeing practitioners as isolated, even reclusive, and perhaps as failing to contribute to the public good in the way that, for example, naval and military men did. In this sense, those we call scientists were vulnerable to the charge of effeminacy. This was often levelled against *accoucheurs*, men-midwives, who in adopting a French name and entering the birthing chamber inspired vitriolic criticism.[14] Medical practitioners were undoubtedly particularly vulnerable to attack. Previously, we noted the fears of surgeons, but physicians were hardly exempt from satire. The stereotypical physician was guilty of pretentiousness, for example. And all types of medical men were regarded with suspicion when it came to their fees. This was a further reason why they were so keen to associate themselves with philanthropic enterprises. Jenner's energetic promoter, the Quaker physician John Coakley Lettsom, is a perfect example of the point.[15] He seems to have been a compulsive philanthropist, with a finger in every available charitable pie. Philanthropy rested on the idea that sympathy with the plight of others was socially valuable, an idea that carried feminine connotations. This is significant because it allowed some scientific and medical men to be portrayed as gentle, even soft, as was the case with Lettsom (illus. 56). Thus some 'effeminate' traits were construed as potentially positive, others as negative.

I have been building up a picture of some of the forces at work in Jenner's time that shaped the ways in which practitioners fashioned themselves. These forces could be responded to in a variety of ways, but whatever route was chosen, the result had to conform to prevailing expectations concerning masculinity, which were freighted with assumptions about class. If scientists were to be a special kind of public servant, not necessarily working for the government but acting for the public good, they had to elaborate an appropriate and manly role, which could not simply be that of the gentleman. This role had to suggest politeness and respectability, expert knowledge

56 T. R. Poole, *John Coakley Lettsom*, 1809, pink wax medallion on an oval wooden mount, w: 18 cm.

Lettsom was an indefatigable worker for his favourite causes. The Medical Society of London, which he helped to found in 1773, was notable in bringing together physicians, surgeons and apothecaries. Wax portraits were particularly popular in the 18th century.

put to good – i.e. non-subversive – effect. This, I would say, was a form of silent gender.

Readers will have noticed that the period I am concentrating on in this chapter is generally linked with 'romanticism' – a notoriously difficult term to define.[16] In Britain we associate romanticism above all with writers, especially with Wordsworth, Coleridge, Byron, Keats, Shelley and Scott. We further associate it with certain kinds of daring, with a refined sensibility, especially in relation to the natural world, and with a cult of genius, where the genius, although human, partakes of the divine. Superficially, this is a far cry from the worlds of science, medicine and technology. But appearances are deceptive in this case. In the last few decades, scholars have not only been challenging received views of romanticism but also exploring both the importance of science within romantic thinking and the centrality of romantic idioms for practitioners of science.[17]

One of the best-known examples of the last point is Sir Humphry Davy, remembered by later generations as a chemist and as the inventor of the miner's safety lamp (illus. 57). A Cornishman from a modest background, Davy became a major scientific figure in early nineteenth-century London. His activities at the Royal Institution, where he was a successful lecturer, brought him to the attention of a wider public. Davy's writings are elegantly crafted; he was an enthusiastic poet and friendly with such literary figures as

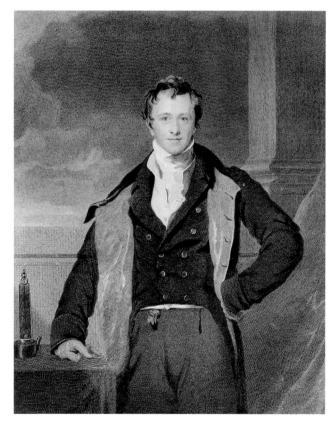

57 G. R. Newton after Sir Thomas Lawrence, *Sir Humphry Davy*, 1830, line engraving, 44.3 × 33.2 cm.
 Given his prominence in metropolitan scientific life, it is not surprising that many images of Davy exist, nor that he was painted by the fashionable Lawrence as a glamorous man.

58 Sir Thomas Lawrence, *Edward Jenner*, 1809, oil on canvas, 75.5 × 63 cm.
 This fairly simple head-and-shoulders format was used by
Lawrence on a number of occasions. His portrait of Jenner came into
the possession of his biographer, Dr John Baron (see illus. 68).

Wordsworth, Southey and Coleridge. In Davy's case 'science' and
'literature' were not separate endeavours, coincidentally practised
by the same individual, but central to his world-view, which can
with some reason be designated 'romantic'.

Portraits were an integral part of this historically specific nexus.
Note, for example, the number of leading scientific and medical
figures who were painted by Sir Thomas Lawrence, with vivid reds
and loose, dashing brushwork. Lawrence's formats were generally
rather traditional, involving the chairs, tables, drapery and limited
accoutrements we have already noted. Yet he imparted to his sitters

102

59 Sir Henry Raeburn, *John Playfair*, 1814–15, oil on canvas, 126 × 100.3 cm.

Raeburn's richly coloured portrait of a major Scottish intellectual uses many familiar devices to show a man of learning. Playfair, who became a Presbyterian minister in 1770, was distinguished as both a mathematician and a geologist.

an attractive verve that is all of a piece with a romantic sensibility. Among Lawrence's heroic sitters were Davy and Jenner, but also Sir Joseph Banks and Thomas Young (from among a number of leading medical and scientific figures) and Henry Lord Brougham, who has been called a 'statesman of science' (illus. 57, 58). Furthermore, Lawrence painted James Watt, whose ideas struck Sir Walter Scott as sublime. Watt was especially highly esteemed by his fellow Scots. In a sense, Sir Henry Raeburn was the Scottish equivalent of Lawrence – his portraits of Edinburgh intellectuals, many of whom were close associates of Watt's – are particularly fine (illus. 59). They included a likeness of James Hutton, medical man and geologist, whose writings were read by Percy Shelley. We can reinforce these multiple links with 'romanticism' by noting Raeburn's portraits of Sir Walter Scott himself.[18]

I find it interesting that a recent biographical dictionary of scientists describes Davy as a propagandist for science, thus suggestimg an ardent desire to foster widespread support for the scientific enterprise. Promoters of science could achieve this through popular writings, public lectures, portraits in a variety of forms and so on. What we call 'romanticism' bears a complex relationship to such efforts. This cultural movement did promote a certain kind of intellectual masculinity that was bold and innovative, that suited a small number of practitioners such as Jenner. Although Jenner was painted by Lawrence, the portrait that best exemplifies this point is John Raphael Smith's pastel of 1800, which became a template for many further representations (illus. 60). It is set in a country scene that includes cows and dairymaids. Jenner himself is quite the country squire, leaning against a tree in a relaxed pose. Commentators often stressed his palpable masculinity by mentioning his love of horses, hunting, drinking songs and country life. In the context of his brilliant innovation, these traits could be read as 'romantic'. A romantic hero was by definition unique, and hence this idiom could only really be applied to very limited numbers of scientists and medical men. It certainly reinforced the sense that great leaps

forward were made by the very few – an assumption that remains to this day despite concerted attempts to convey to a wider public the importance of collaboration and teamwork, which have long been important in the study of the natural world. So, romantic heroes in science, medicine and technology such as Davy, Jenner and Watt arose at a specific time and this is significant. The cultural type they exemplify is also a strategic fiction that is sometimes useful while also being misleading. It has allowed the stereotype of the lonely, struggling, suffering genius to persist, and sometimes to be used rather manipulatively. What room was there in this powerful imagery for women?

GIRLPOWER

Caroline Herschel and Mary Somerville provide two somewhat different examples of the roles available to women in a scientific context. I have already indicated that Caroline's route in was through her brother, who came to England in 1757 as a musician, although he was increasingly taken up by his passion for astronomy. William's son, John, to whom Caroline was extremely close, became a distinguished man of science, also in the field of astronomy (illus. 5). Thus her access into scientific activities was through her immediate family. William invited her to join him in England in 1772, and she remained there, acting as his assistant until his death in 1822. She lived a further 25 years, during which time she became both a celebrated old woman and an active correspondent with her nephew and his family, encouraging his career at every possible opportunity. Without doubt, part of her fame rested on the simple fact of her longevity – she died aged 97 in full possession of her faculties. This lent retrospective lustre to her scientific work.[19] We need to be clear just what this work consisted of.

William Herschel's main interests were in the development of instruments and the recording of observations. For example, he discovered the planet Uranus in 1781. The work he undertook,

whether observing the skies or building telescopes, was exception-
ally labour-intensive, and so his sister, whom he 'trained', came to
be important not just as another pair of hands but as a skilled
observer in her own right. As a result, her contributions to science
were publicly recognized. However, the apportioning of scientific
achievement is always a difficult issue, wholly dependent on how
the various activities it comprises are rated. A biographical dictionary
describes Caroline as an 'astronomical *observer*' (my emphasis) and
her brother as an 'astronomer' who 'discovered Uranus, the Sun's
intrinsic motion through space and the true nature of the Milky
Way'.[20] There is without doubt a difference of inflection here, one
that is also registered in the only publication that bears Caroline's
name as author, a star catalogue of 1798. The lengthy title of this
work, which was published by the Royal Society, makes clear that
she was building on earlier work by John Flamsteed, the first
Astronomer Royal, and that her contribution was being glossed by
her brother. William's introductory remarks make readers aware
of the division of labour involved: 'By inspecting the work as it
proceeded, and looking over all cases which seemed to require more
of the habits of an astronomer than she has been in the way of
acquiring, I have endeavoured, as much as I could, to prevent errors
from finding their way into the work.'[21] Caroline was cast as under-
labourer in need of supervision. As a man, William was naturally
elected to a Fellowship of the Royal Society; this occurred in 1781.
Caroline was not eligible for this honour; the election of women
remained an issue well into the twentieth century. She *was* widely
fêted, but in a quite distinct idiom. She was her brother's devoted
assistant; this involved, it was freely acknowledged, extremely
arduous work and considerable physical hardship, such as spending
whole nights outdoors. The point about her devotion is that it was
selfless; this is a persistent motif in all publications about her and fits
easily with one particular view of femininity.

Caroline received further forms of public recognition in addi-
tion to her publication – an annuity from the King, for instance.

60 John Raphael Smith, *Edward Jenner*, 1800, pastel, 45.2 × 35 cm.

Smith's delicate pastel has spawned numerous derivatives. The results are quite diverse, so that in effect many Jenners have been produced from a single template.

Furthermore, she was awarded a medal by the Royal Astronomical Society in 1828 and made Honorary Fellow in 1835, at the same time as Mary Somerville. That gender was a major issue at the time is clear from the letter Somerville wrote to Caroline Herschel on this occasion, which expresses her sense of honour at the coincidence of their election and thereby acknowledges their shared, and peculiar, situation as women.[22] Caroline was well known; people talked about and were interested in her, they visited and corresponded with her. Hence her portraits were of some interest. Yet, in British collections there are few of them, in marked contrast to portraits of her brother William. The best-known one was used as frontispiece to her *Memoirs and Correspondence*, first published in 1876 (illus. 61). Two features stand out: the row of stars, a delicate and delightful touch, and the 'dear old lady' role in which she was depicted. There is a little more evidence on the matter of Caroline's portraits. In a letter of 1847, written shortly before her death, Caroline's companion commented on a drawing by an unnamed painter: 'I am sorry to say the drawing which I saw did not do justice to her intelligent counte-nance; the features are too strong, not feminine enough, and the expression too fierce. . .'[23] The femininity of the woman scientist and the *depiction* of her femininity remained contentious matters.

Before turning to Mary Somerville, whose role was that of writer rather than tireless helper, I want to consider briefly portraits of William Herschel. William was more extensively portrayed than his sister, in terms not just of the number of portraits but of the range of visual idioms deployed. There is, for example, the marvellously crisp and lucid head and shoulders painted by Lemuel Abbott in 1785, a bust of 1787 and a number of prints (illus. 62). By far the most striking image is a mezzotint based on a portrait by Friedrich Rehberg, taken from life in 1814, when William was 76 years of age (illus. 63). One of its most notable features is the outdoor setting, with stars in the night sky and schematic branches that evoke a sense of barren space. William's body occupies a great deal of the picture space, and he gazes out of it, presumably at some other

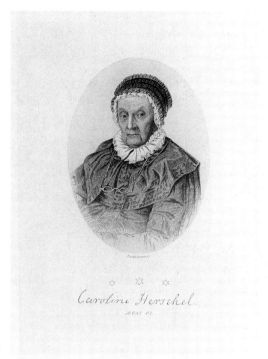

61 Joseph Brown, Stipple engraving showing Caroline Herschel aged 92, 1847, 27.9 × 20.5 cm.

As a young woman, Herschel undertook dressmaking and singing. After she joined him in Bath, her brother William instructed her in many subjects, including music. Only later did she become absorbed by astronomy.

piece of sky. The overall effect is extraordinary and unusual. Clearly, stars and setting convey information about William's particular scientific enthusiasm, but such a description fails to do justice to the powerful aura of this portrait, which somehow breathes with the distinctiveness of the sitter. There is, of course, one perfectly obvious way of naming what is most arresting about Rehberg's work – it is 'romantic', and possibly it is romantic in a distinctively German way, although such a claim is not one I feel altogether comfortable with. Herschel here is not bewigged and formally dressed but presented as a man (looking rather like Beethoven!) in the world of nature. My sense is that outdoor settings have been rare in scientific, medical and technological portraits, although I have no ready explanation for why this should be, given the huge popularity of natural history and of cognate fields, such as geology, which involved manly outdoor activities, for most of the period under discussion here.

62 Lemuel Francis Abbott, *Sir William Herschel*, 1785, oil on canvas, 76.2 × 63.5 cm.
As a prominent scientific figure, Herschel was depicted a number of times, and derivative prints made. He was in his late 40s when this image was created. He married three years later; it was to his only son, John, that his sister Caroline became so devoted.

As I have already hinted, Mary Somerville, born 30 years after Caroline Herschel, had a somewhat different career and reputation, although the theme of monitoring femininity remains. Somerville's education was exceedingly hard won. Her second marriage, which took place in 1812 to her cousin, William Somerville, a widely travelled medical practitioner and a Fellow of the Royal Society, brought dramatic improvements. Mary had little formal schooling of any kind, but she did receive instruction in art and was a competent artist whose friendship networks included professional artists and sculptors. Her extensive scientific, medical and cultural contacts were an important feature of her life. Somerville has been described as a 'popular writer on scientific subjects', but this could easily mislead, precisely because 'popular' can carry the pejorative connotations of 'rendered simple' or 'intellectually undemanding', neither of which would apply in this case.[24]

Almost without exception, heroic tales in the fields we are concerned with involve a precocious, ardent thirst for knowledge.

63 James Godby after Friedrich Rehberg, *Sir William Herschel*, 1814, stipple engraving, 34.7 × 25.7 cm.

The night sky is a particular feature of this portrait, which presents an older Herschel as a contemplator of the heavens, a man gazing into infinite space.

Mary Somerville is no exception; all biographical accounts stress both her early desire for learning (and for mathematical enlightenment in particular) and the numerous ways in which this was thwarted by her family and her first husband. However, the manner in which she achieved fame was quite distinctive, as well as indicative of her gender. Effectively, Somerville was an autodidact, whose career began when she was middle-aged with considerable family responsibilities. The precise manner in which it began is extremely revealing. It was at the suggestion of Henry, Lord Brougham, a key figure in scientific as in political networks and a friend from Edinburgh days, that she wrote her first book, *The Mechanism of the Heavens*, published in 1831. Brougham's initial contact, however, was made through Dr Somerville, not directly with Mary. This work was a rendition of the *Mécanique céleste* by Pierre-Simon de Laplace, the brilliant French scientist, published in five volumes between 1799 and 1825. In this sense, it was not 'original', and it was designed to bring the ideas of a man frequently compared to Newton to a wider audience. In these ways, it was indeed a work of popularization, like Somerville's later, also highly successful publications.

I want to probe a little further Somerville's role as a scientific *writer* (illus. 64). It is worth being somewhat emphatic about the importance of scientific writing, a phrase that includes a wide range of genres. I mentioned earlier the claim that Sir Humphry Davy was a propagandist for science – much scientific propaganda took the form of writings accessible to a wide educated public. If the value of the sciences and scientific values were to receive broad support, which was certainly necessary if significant amounts of public money and institutional resources were to be assigned to them, they had to be disseminated *effectively*. During the nineteenth century, the medium of print was the principal vehicle for doing this, and for quite precise reasons. Audiences for science wanted to understand as much detail as possible, and there was a healthy publishing market for a wide variety of publications on topics in science, medicine and technology. Despite being presented as 'popular', some of these

64 Mary Dawson Turner after Thomas Phillips, *Mrs Mary Somerville*, lithograph, 23.5 × 17.2 cm.

Mary Somerville presented as a youthful, attractive woman.

were in fact quite demanding, especially by modern standards. For example, Dionysius Lardner, who was also a scientific writer, published *The Steam Engine Explained and Illustrated*, which went through many editions, having originally been published as *Popular Lectures on the Steam Engine* in 1828 (illus. 65). The frontispiece was based on Chantrey's statue of James Watt (illus. 32), and the work is dedicated to Henry, Lord Brougham. Thus much scientific writing in the nineteenth century served to impart considerable knowledge to a literate public, including, in Lardner's case, technical engineering details.[25] At the same time, the great innovators were to be revered, so that such writings also served to make the lives of scientists known and available for the purposes of emulation. We have already noted the importance of biography as a genre and its close relationship with portraiture. The publication of scientific lectures was also popular. Faraday initiated what has become a long-standing and

65 Daniel Maclise, *Dionysius Lardner*, 1832, lithograph, 29.3 × 21.6 cm.

The Irish-born Lardner was a prolific scientific writer and publishing entrepreneur with wide interests. He was a member of a growing group of people who brought science to wider audiences without themselves being active creators of scientific knowledge. An Irish painter, Maclise lived much of his life in London, undertaking some major public projects, including murals for the Houses of Parliament.

much-loved tradition in 1826 when he gave Christmas lectures for young people at the Royal Institution, many of which were pub-lished.[26] Such works also introduced the public to the wonders of science by generating both an excitement about natural phenomena and an awe for the intellectual powers required to explain them.

The point, then, about Mary Somerville is that scientists as well as promoters of science such as Lord Brougham trusted her both to get to the heart of a work like Laplace's and to present it accurately and with conviction to English readers. As a result of her books, Somerville enjoyed an international reputation for scientific exposi-tion and synthesis, which was enhanced by her extensive travels and networks of contacts, the latter based, at least initially, in intellectual circles in her native Scotland. It is when we consider Somerville's public reputation that the links with Caroline Herschel appear. Accounts of Somerville cast her as scientific handmaiden rather

than scientific creator, which is probably more or less fair, but they also insist on her being a nice woman, pretty, unaffected, devoted to her children. Thus the idioms in which she was presented were coloured by assumptions about gender.

Compared to Caroline Herschel, Somerville was depicted extensively. Her publisher, John Murray, commissioned a portrait of her from Thomas Phillips in 1834, which now hangs in the Scottish National Portrait Gallery in Edinburgh. Although Somerville was about 54 at the time it was painted, the half-length canvas shows a youthful and alert figure, with a soft ruff and no visible accoutrements (illus. 64). Murray commissioned a number of portraits of his distinguished authors, including Sir Walter Scott. It was at this time that the Royal Society commissioned a bust of Somerville by Sir Francis Chantrey – already a friend – which proved to be a drawn-out and somewhat troublesome process, but which provided one of the best-known images of her. Other depictions include a portrait by John Jackson, who painted many scientific figures, a possible self-portrait and several medals. One of the latter, by the distinguished French sculptor David d'Angers, was criticised on the same grounds we have encountered in connection with Caroline Herschel, for being hard, unfeminine.[27]

Somerville received acclaim and honours and later had an Oxford college named after her; contemporaries always commented not just on her exceptional abilities as a woman but on her woman*liness*. I am suggesting that depictions of her and commentary on them, which invariably suggest that she looked unusually young for her age, served to make her seem considerably safer, less threatening than she otherwise might have done. As with other public figures, portraits circulated as mementos. This was particularly true of portrait busts, prints and photographs. Somerville's public life was organized around the idea of an exceptional woman: ironically, this was possible because she was, in her physical appearance and in representations, ordinary – that is, she was appropriately feminine in both deportment and appearance. Portraits of her were tokens of both these traits.

Inevitably, heroism is hard to define. It varies with historical period, geographical area and domain of achievement. And, when put into practice, it has to be malleable enough to fit a range of individuals, women as well as men, the ugly as well as the beautiful, for instance. Heroism meets needs that exist at a particular moment – the fact of exceptional achievement is clearly not enough; rather, a specific enmeshment occurs between hero/ine and setting. I have been suggesting that science, medicine and technology are complex areas when it comes to heroism, especially in Jenner's time. In the twentieth century, when most societies are gorged with their success and daily life affirms their indispensability, scientists as a cadre are aware of their own value and accept the patterns of heroism that have emerged over the last century. In the 1700s, the situation was rather different – success, public esteem and so on had to be cultivated. New forms of scientific, medical or technological heroism were forged out of available materials. So some of the elements I have noted, such as precocity, were already parts of typical heroic narratives.

Our interest here is in one particular form that the celebration of heroes took, their visual depiction. This has long antecedents, which were constantly drawn on in Jenner's time, especially the enthusiasm for medals and for portraits that deployed visual idioms associated with them (illus. 66). Many medals included portraits, but sometimes the name of the scientific achiever sufficed. For example, in 1801 the naval medical officers presented Jenner with a medal. On one side was an anchor and a few words recording the King's name and that of Earl Spencer, who was in charge of naval administration at the time. On the other side, in the words of John Baron, Jenner's biographer and devoted friend, 'Apollo the god of physic [is] presenting a young sailor just recovered from the vaccine inoculation to Britannia who in return extends a civic crown on which is written the word Jenner' (illus. 67, 68).[28] In this case, the achievements can be evoked by the name alone. Traditional here

66 F. W. Loos, Circular medal in honour of Edward Jenner, 1796, silver, d: 3.5 cm.
 This very early medal commemorating Jenner deploys the bucolic theme that is also
evident in Smith's portrait (illus. 60).

were the medal form, the neo-classical figures and the idea of
personification. In the case of Pond's portrait of Mead, for example,
the use of a profile on a plain background and the inclusion of a
Latin motto recall earlier visual patterns (illus. 11).

 The mere commissioning of a portrait could be an affirmation of
the heroic, or at least the very special, status of the sitter. We have
seen that the magnificent portrait of Elias Allen surrounded by
his mathematical instruments is indicative of his significance in
mathematical and collecting circles (illus. 29). He was friendly with
Thomas Howard, Earl of Arundel, a famous courtier and collector;
the original painting of Allen was by van der Borcht, who was in
Howard's employ. Richard Mead owned a portrait of Howard by
Rubens; pictures, themselves evidence of the status of both artists
and sitters, circulated, their status rubbing off on their owners in
the process.[29] A full-length oil in a grand setting was certainly one
way of affirming a sitter's achievements. Heroism could hardly be
achieved by visual means alone, although specific images could
make a significant contribution to the creation of a reputation, as
Smith's pastel of Jenner did (illus. 60). Thus we might want to add
that one definition of a hero is that he or she becomes widely recog-
nized in a variety of cultural forms. The name acts as a familiar tag,

EDWARD JENNER, M.D.

L.L.D. F.R.S. &c. &c.

Drawn from the Bust by H. CORBOULD. and on Stone by R. J. LANE.

Printed by C. Hullmandel.

Published March, 1827, by Henry Colburn, London.

67 Richard James Lane after Henry Corbould, Bust of Edward Jenner, frontispiece of John Baron, *Life of Jenner* (1827), lithograph.

A number of busts of Jenner were made during his lifetime, and prints of them were available. This image was used as a frontispiece in both the 1827 and 1838 editions of Baron's biography.

and the face or aspects of personal style are flexible elements that become usable in a variety of forms. In the two hundred years since Smith produced his pastel, elements from it have appeared in a number of prints and book illustrations and also on commodities, such as a mug on sale at the Jenner Museum (illus. 16). The incessant repetition and adaptation of images is a form of visual heroism, one that only relatively few scientists have enjoyed (illus. 69, 71–3). It is, in fact, a form of stardom.

We might want to consider further elements commonly associated with stardom and heroism. There is a constellation of related features whose relevance to science, medicine and technology we need to assess. In the twentieth century, stars are expected to be

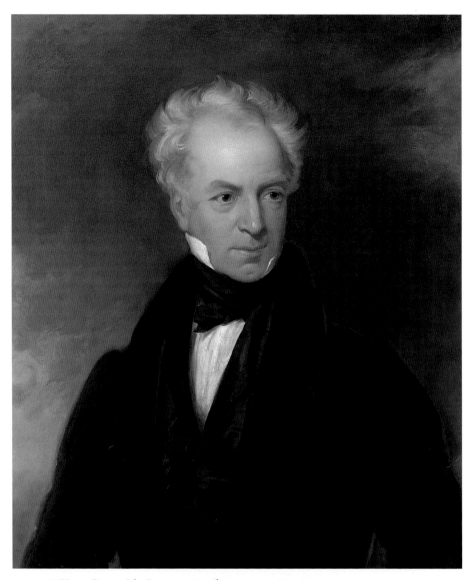

68 Henry Room, *John Baron*, *c*. 1838, oil on canvas, 76.8 × 63.7 cm.

Baron studied medicine in Edinburgh and practised for a long time in Gloucester. He got to know Edward Jenner, who lived near Gloucester, around 1809, and they became close friends. As Jenner's biographer, Baron had a huge impact on views of the man he so ardently admired.

glamorous, to exhibit a certain magnetism, elicit a kind of desire in others and be simultaneously distant as an object of emulation and appreciably human (and therefore, in a certain sense, ordinary). I am well aware of the differences between heroism and stardom: the former implies the possession of extremely special, sometimes divine or quasi-divine traits, and the performance of special tasks or feats, while the latter implies a generally recognized allure which may or may not go along with talent. But the notion of stardom is useful nonetheless. Largely a creation of the mass-culture, multi-media, world of the last hundred years or so, it can be used to draw our attention to the ways in which a public image can be manufac-tured, and to the important role that visual media play in such a creation. We can admit that styles and preferences change, but the idea that outstanding figures are knowingly fashioned is worth taking seriously. Until relatively recently, the sciences were allowed

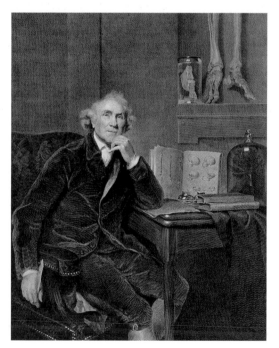

69 William Sharp after Sir Joshua Reynolds, *John Hunter*, 1788, engraving, 53.4 × 40.5 cm.

Reynolds made Hunter look considerably more urbane and polished than he was generally considered to be. The two men's networks overlapped because Hunter's wife, Anne Home, who wrote poetry, moved, as did Reynolds, in London literary circles.

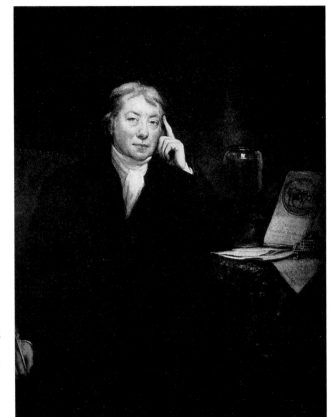

70 After James
Northcote, *Edward
Jenner*, 1803, photo-
gravure.

This photogravure
is based on the second
of the two portraits
Northcote undertook
of Jenner. Both show
him as a learned man
with significant
accoutrements.

71 *Edward Jenner*, between 1880 and
1890, stained-glass window from a
London house, 45 × 44.5 × 0.8 cm.

Like the many medals struck to
commemorate Jenner's achieve-
ments, this stained-glass window
suggests how widespread and
enduring the wish to honour
him was.

the reverse of glamour, as in the stereotype of the eccentric, ill-dressed, dotty but fearsomely clever male scientist. Yet in the period since the Second World War, the situation has changed, and it is now expected that the sciences, generously defined, widely seen as ground-breaking, should be undertaken by at least a few individuals who can be treated as stars. Perhaps the kinds of heroism that were so important in the eighteenth and nineteenth centuries have become less so, at least in *intellectual* fields. In recent times, extraordinary achievements of a physical kind remain prominent forms of general heroism, as does the endurance with dignity of terrible, drawn-out suffering. But at the moment, there are only a very few exceptionally prominent scientists – they have to be able to deal adroitly with the media in order to enjoy a high public profile. I am suggesting that perhaps they are more stars than heroes or

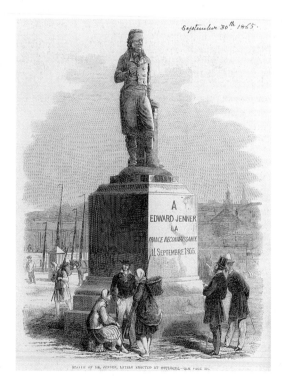

72 *Statue of Dr. Jenner, lately erected at Boulogne,* 30 September 1865, newspaper engraving, 28.4 × 18.9 cm.

Jenner's fame spread quickly, and he was commemorated across the world. Of course there was considerable interest in Britain in such acts of homage.

73 Jenner-related objects on display in the Wellcome Historical Medical Museum, London, photographed between 1913 and 1926, bromide print.

Sir Henry Wellcome was a medical collector with notably broad interests and huge financial resources. A Jenner enthusiast, he was able to acquire an already existing collection of 'Jenneriana'.

heroines. And here we can usefully return to questions of gender.

Susan Greenfield was already in the public eye when in 1998 she was appointed the first-ever woman director of the Royal Institution, founded in 1799 (illus. 74). Young, attractive and lively, and extremely willing to put the case for science to a wide public, she epitomizes broader trends in the public presentation of both science and scientists. There is no doubt that the interest in women scientists has been growing for some time, especially among feminist historians. Partly prompted by questions about the different cognitive styles of men and women, there have been numerous attempts to rediscover

NEWSLETTER

THE ROYAL INSTITUTION July 1998

NEW DIRECTOR TAKES OVER......

PHOTO: THISTLE PHOTOGRAPHY

On June 26 the Council announced the appointment of Professor Susan Greenfield to succeed Peter Day as Director. Professor Greenfield will take up her appointment on 1 October.

The Council were unanimous in their choice of Professor Greenfield, who is the first woman scientist to occupy this prestigious science post.

"There were a number of very strong candidates" says Andrew Osmond, on behalf of the Council *"but in the end we felt that at this point in the Institution's development, we needed a Director who was not only a first rate scientist, but also someone with strong communication skills who would help us to*

promote the RI and what it does, to a wide audience"

"Presenting the televised Christmas Lectures several years ago – she was the first woman to do so – brought Susan to the attention of the media in a way which I am sure she will exploit for the benefit of the RI during her directorship. I wish her well and look forward to working with her."

Interviewed at her home in Oxford, Professor Greenfield told the Newsletter: *"I feel enormously privileged to be able to now combine my main professional interests – basic research into neuro-degeneration – and at the same time be able to make a contribution towards the RI realising its full potential in the next century."*

"The RI is a very special place at the centre of scientific research and communication. Although it has always met the public need to understand the science going on around them, the possibility for science to change our lives is greater than ever before, creating new prospects and new challenges for the Institution as we move into the new millennium."

ABOUT THE NEW DIRECTOR...

Professor Greenfield is an accomplished scientist, pre-eminent in her chosen field of brain degeneration and the inspirational leader of a team at Oxford dedicated to developing better diagnostic and therapy procedures for neurodegenerative disorders.

Her media experience is extensive. She writes a column in the

Independent on Sunday and contributes regularly to radio and TV. In the forthcoming year she will be presenting a major six part television series on the brain and the mind. She is also the author of several books on the brain. *'Journeys to the Centres of the Mind'*, *'The Brain – a Guided Tour'* –which made the best seller list – are examples of her literary output.

A graduate of St Hilda's College Oxford, Professor Greenfield worked for her DPhil at the

University Department of Pharmacology. Having completed her thesis, she went on to post doctoral fellowships in the Department of Physiology, Oxford, the College de France in Paris and the Medical Center at NYU, New York. She is now Professor of Pharmacology at Oxford University and Fellow and Tutor in Medicine at Lincoln College. She is also currently Professor of Physic at Gresham College in the City of London.

74 Professor Susan Greenfield, from the *Newsletter* of the Royal Institution, July 1998.

In 1998, Greenfield became the first woman Director of the Royal Institution, founded at the end of the 18th century to promote scientific research that would be useful to society as a whole. Davy and Faraday were among its most renowned members. The RI has important collections of portraits, books, instruments and other items connected with science.

women who had previously been ignored and to reassess their achievements. I think that women who succeed in male-dominated worlds elicit a special curiosity. The example of Marie Curie, probably the most famous woman scientist, is particularly interesting. Curie has hardly been ignored, so she does not require recuperation, but she continues to intrigue us because she inhabited a world totally unused to women like her and did indeed experience considerable hostility. She is a heroine in a number of respects, winning the Nobel Prize *twice* being an obvious one. Equally important are the sacrifices that she willingly made in the cause of science, to adopt idioms familiar to us from rhetoric that glorifies scientific achievement. There are numerous memorable images of Curie, many of which locate her in the laboratory. The sketch of her that appeared in a French periodical in 1911, when she was a candidate for election to the Académie des Sciences, an honour she never actually gained, is revealing (illus. 75). As happens so frequently, depiction and commentary work closely together. The text describes her person, her deportment and demeanour, and is fully attentive to her femininity. Curie, like Greenfield, was an active scientist, not a writer or a helper. Unlike Greenfield, she was a controversial figure whose position within the French scientific community was never fully secure. Thus it was important to stabilise the difficult issues raised by her success by means of her public image of which portraits were but one facet. Curie is an especially interesting case because, as the recent biography of her shows so powerfully, her affair with another scientist after her husband Pierre's death caused a major scandal: she was much vilified, for being a foreigner in France among other things. Yet she managed to carry on with her work, earning considerable public support for her contribution to the medical use of X-rays. While portraits could not redeem her morally all by themselves, they are an integral part of the public presentation of scientists, often in close association with biographical accounts. It is worth noting Curie's status as a (devoted) mother, which was often emphasized by commentators. One of her two

M^{me} CURIE

Professeur à la Sorbonne, candidate à l'Académie des sciences.

Portrait d'après nature de PAUL RENOUARD.

Assez grande, la taille bien prise, n'arrivant pas à dissimuler sous la froideur professorale une certaine souplesse de ligne, tout de noir vêtue, sans la moindre tache lumineuse au corsage, si ce n'est parfois un mince sautoir d'or, M^{me} Curie étonne d'abord par l'extraordinaire profondeur d'un regard qui semble presque perdu dans d'extatiques visions. Puis c'est une légère désillusion de l'entendre d'abord « réciter » son cours, n'osant aucun geste, en apparence intimidée par l'auditoire et tourmentée par la crainte d'oublier la leçon apprise.

La diction très claire, d'une pureté admirable, à peine coupée de temps à autre par une intonation étrangère, devient peu à peu moins monotone ; on s'y habitue, pour ne plus apprécier bientôt que la correction d'une langue châtiée sans afféterie et la précision toujours accessible de l'enseignement. De temps à autre, l'illustre professeur aide son préparateur à réaliser une expérience ou crayonne sans hâte une formule au tableau. On oublie si l'on écoute un homme ou une femme ; on ne considère plus que l'être abstrait, dispensateur d'une science étrange qui semble appelée à nous révéler les plus profonds mystères de la matière.

Et, parmi les nombreuses jeunes filles attentives aux leçons de M^{me} Curie, quelques-unes sans doute entrevoient le jour où, profitant d'une évolution plus avancée de nos mœurs, elles pourront, elles aussi, envisager l'Institut comme la récompense suprême de leur labeur, sans voir s'élever contre elles l'hostilité irréductible des traditionalistes.

75 Paul Renouard, *Mme Curie*, from *L'Illustration*, 14 January 1911.

Among the general public, Marie Curie is one of the best-known scientific figures. Her austere appearance has become a significant aspect of her image. It fits well with features of her personality that are repeatedly stressed in biographical accounts, such as her phenomenal self-discipline and her willingness to sacrifice herself in the cause of science.

daughters became a successful scientist; the other wrote a widely read biography of her mother.[30]

Portraits can do this social and cultural work because there is an extensive and widely recognized range of visual devices for endowing an individual with heroic qualities. These devices are extremely flexible, enabling images simultaneously to meet the needs of the time, use the peculiarities of a given person creatively and speak to specific issues within the worlds of science, medicine and technology at any given moment. Forms of heroism necessarily change, even as old tropes are redeployed. In the second half of the twentieth century, women have been cast into new roles; these fit with broad cultural shifts, which have, among many other things, put an increasing emphasis on glamour.

IV

PORTRAITURE IN PRACTICE

Lesley J. Yellowlees

CHEMISTRY

Chemistry, science, I love it all. But how to get the excitement and the wonder across to the uninspired is the challenge. How to explain the concepts, the theories, the thoughts in simple everyday language requires a clarity of expression not easily learnt, but once mastered is tremendously rewarding. To encourage everyone to want to understand scientific thought, or at the very least to be willing to meet me part way down the road, is what I strive for.

One invigorating project I have been involved in which has allowed me to develop these ideas has been the Girls Get Smart club. A significant aim of this work is to convince schoolgirls that they can have a future in science, engineering or technology.

I enjoy the stimulation of research at the cutting edge – my own particular interest is in electrochemistry – what happens to chemical systems on the addition or removal of electrons. Some of my research interests are 'blue skies', some of immediate use to our 21st century lifestyles. All of it, teaching and research, involves team work and on many days it is the personal interactions which are the most successful. But there is more to life than chemistry; family, friends, laughter, holidays and perhaps golf have their part to play in my life.

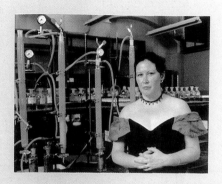

76 Spread from the 1997 catalogue *Portraits of Excellence* including Tricia Malley's portrait of Dr Lesley J. Yellowlees.

One of the main purposes of this chapter is to consider the range of social situations in which portraits are created. Let us start with a specific example, the vivid photograph of Lesley Yellowlees, which formed part of an exhibition, *Portraits of Excellence*, first displayed in Edinburgh in 1997 (illus. 76). All the sitters were academics at Edinburgh University, and the title itself reveals an institutional agenda. The photographers were Tricia Malley and Ross Gillispie, who are employed by the University. The full resonance of the image cannot be appreciated unless it is seen both as part of a series and as a successor to a number of portraits by Sir Henry Raeburn, undertaken at the end of the eighteenth and very beginning of the nineteenth centuries, which now hang together in a beautiful room in the 'Old College' of Edinburgh University. The debt to Raeburn was made perfectly explicit by participants in the *Portraits of Excellence* project. The original exhibition and subsequent book contained twenty-six portraits of academics from diverse fields – six women, twenty men, ten scientists, of whom three were women (illus. 77). The entire undertaking is thus a rich source for insights into various issues: the contemporary portrait practice of institutions, how intellectual achievement is currently being represented in photographs, the visual expression of differences between academic fields, and gender distinctions. A wide range of visual styles is deployed, in black and white as well as in colour.[1]

Thus it is worth taking a closer look at the Yellowlees image. Here is a woman in a laboratory. She is middle-aged and dressed in a manner that surprises, perhaps jolts, viewers, given her surroundings. The colour of her sleeves rhymes with that of the tubes beside her; apparatus and person are side by side. Without further

77 Spread from *Portraits of Excellence* including Tricia Malley's portrait of Clive Reeves.

This image offers a strong contrast with illus. 76 in that it is simple, even austere, without any hint of playfulness. The two portraits explore common assumptions about gender; the extent to which they do so knowingly is hard to assess.

information, this image is provocative because we bring to it an array of assumptions about scientists, women, clothing and scientific settings that it immediately challenges. In fact, it is difficult to place this image, both emotionally and chronologically; evening dress is unexpected in a place of work, and the apparatus, like the dress, is not easy to date. In my experience, viewers react strongly to this portrait, both positively and negatively; feelings about gender and sexuality are a central component of those reactions.

The woman in question is Dr Lesley J. Yellowlees, then Senior Lecturer and now Reader in Chemistry at Edinburgh. Note that in the book we also have her signature, a common device in the nineteenth century for supplementing the sense of individuality of a depicted person, and a short commentary by her, which can be read as a further affirmation of authenticity. What comes across from her comments is tremendous energy, a commitment to science and to bringing more women into science, certainly, but also an insistence on balance: 'there is more to life than chemistry.' It is essential

to remember that this project was designed to present one particular university to a wider public, to show it to good advantage through portraits of those who teach and do research there. It is, in other words, a highly specific form of display. The corporate project, however, had to work through and with individuals who were extremely diverse not just in terms of fields and age but also in terms of personality. The end results are frozen moments from an engagement between a small number of human beings – sitter and photographers – in a given institutional setting. A complex array of economic and political forces have made universities exceptionally attentive to their public image – the concern of the University of Edinburgh about their public image shines out from *Portraits of Excellence*. I do not know precisely how the individuals portrayed were selected from the huge numbers of potential sitters, but it is not difficult to imagine at least some of the criteria that came into play, whether consciously or unconsciously: diversity of fields, celebration of achievement, representation of women as well as men and younger as well as older scholars, and visual interest.

Yellowlees's own response to the project is revealing. She notes, for example, that many, many shots were taken. The final choice was the only one not to show her smiling or laughing and hence, according to her friends, is *not* particularly like her. I first encountered this image through an article about the Edinburgh project that appeared in the *Times Higher Education Supplement* in January 1998. The journalist commented, '. . . here, Lesley Yellowlees . . . poses in her lab, in a ballgown, to show that one can be both feminine and a scientist.' No evidence for this interpretation is given; indeed it is presented as self-evident. The article was accompanied by a cropped black-and-white reproduction, thus giving a different shape and feel to the image. According to Yellowlees, '. . . what I wanted to depict was that although I love my science there is more to life than chemistry'. That is, she sought to evoke the pleasures of her life as well as her work.[2] It is worth commenting too that this is not 'her' lab but a teaching area.

One implication of my argument is that there are multiple contexts and practices underlying any given portrait. Portraits generated by institutions enable us to discern those contexts and practices particularly vividly. For example, it has been persuasively argued that the Raeburn portraits, which are now an important element in the University of Edinburgh's cultural identity, should be seen in the context of the Scottish Enlightenment, whose concerns and values Raeburn articulated.[3] He worked in a context that rated certain kinds of intellectual achievement extremely highly – the polite, humane and civilizing knowledge embodied in the leading lights of Scottish, especially, Edinburgh, culture. Science, medicine and engineering were central to this ethos. Early in his career, Raeburn painted James Hutton, medical practitioner and geologist. Later, he portrayed many distinguished men of science, including Adam Ferguson, John Robison and John Playfair, whose interests spanned a wide range of topics within natural philosophy and mathematics (illus. 59). Natural philosophy embraced many fields in what would later be described as pure and applied physical science. It was precisely Raeburn's *artistry* that enabled him to pick up these currents, to respond to sitters and then to produce *visually* satisfying results. In asserting his artistry, we are not just saying that he was technically a good painter, but that he interacted with his subjects and their circumstances in such a way as to produce something called 'art'. I therefore note with interest that the Vice-Principal of Edinburgh University, the sociologist Professor Colin Bell, has claimed about *Portraits of Excellence* that '. . . this exhibition is art rather than documentary'. Presumably Bell intended 'art' to be elevating, which would be consistent with his emphasis on 'a truly great institution'.[4]

How are we to understand such artistry? As Edinburgh photographer Tricia Malley herself put it, '. . . portraiture is a two-way street', and indeed it was at the photographers' suggestion that Lesley Yellowlees wore a ball gown.[5] Artist and sitter are collaborators, even co-conspirators. Together, carrying their cultural baggage,

they set out to solve sets of problems, including the visual representation of particular kinds of intellectual achievement. And when the subject is a woman, they have to think, in however intuitive a manner, about gender and specific forms of brainpower. The resulting (finished) image is just one highly artificial remnant of that relationship, which is extraordinarily hard to reconstruct. For past times, only rare glimpses are afforded of this process, and it is part of the historian's job to gather whatever material is available, set it in context and work from there to imagine what occurred. Even in the present such reconstruction will only be partial, as all such reconstructions must necessarily be, and evidence can remain a problem. For example, only one preparatory sketch has been retained by Tom Phillips for his portrait of Professor Peter Goddard, Master of St John's College, Cambridge (illus. 47, 78), commissioned shortly after Goddard assumed his post.

78 Tom Phillips RA, Preparatory work for portrait of Professor Peter Goddard, 1996(?), oil on board, 22.7 × 17 cm.

This, the sole surviving sketch for Goddard's portrait, shares some features with the finished version, but its vertical format lends it a rather different feel.

Although details of the commissioning process vary from institution to institution, the fact remains that more formal portraits in the sciences mostly have their origins in either academic or professional organizations. They would generally seem to offer the sitter some say over the choice of artist, but retain strong overall control. Much depends on who the chosen artist is and on their manner of working, conversational skills and demeanour with sitters – that is, on every aspect of them as a person. Sitters are naturally concerned about the resulting image, and increasingly about spending precious time with a person they may not find congenial. Although, as I noted earlier, in studies of portraiture more attention is generally paid to sitters than to artists, it is nevertheless probably easier for artists to record their thoughts about their practice, especially if they are well known, than it is for sitters to convey their reactions.[6]

I would suggest that we can get a little further with these matters if we compare the portrait practices of institutions with one another. *Educating Eve: Five Generations of Cambridge Women*, an exhibition and book containing 50 photographs of women associated with the university, can usefully be compared to *Portraits of Excellence*.[7] The former includes students as well as career academics; it only includes women, of whom eighteen could be described as having had some involvement with science, medicine and technology. The two enterprises have four important features in common: the medium, photography; the celebration of a university; the recording of distinction, especially intellectual; and the giving of a voice to sitters. Yet, visually speaking, there are also significant differences. All the Cambridge portraits are black and white, taken by a single photographer and solidly within established pictorial conventions. In these respects, the Edinburgh project is considerably more adventurous on a visual level. On the other hand, the inclusion of signatures is quite old-fashioned; they are not there in *Educating Eve*. Of the eighteen scientists, in which I am including mathematicians, doctors, engineers and so on, five are depicted with accoutrements relevant to their field (illus. 79). For example, the crystallographer

79 Julia Hedgecoe, *Olga Kennard*, 4 June 1998, photograph.

The X-ray crystallographer Olga Kennard is shown as an elegant and, by virtue of the book on her lap, contemplative woman. The molecular model neatly sums up her scientific achievements.

Olga Kennard, who is shown reading, has a molecular model by her side, and Wendy Savage, the gynaecologist and obstetrician, is shown in a hospital setting, including an incubator, sitting on an empty bed. It strikes me as rather ironic that the bed and incubator are empty – endowing the image with austerity – given Savage's well-known commitment to freedom of choice for women patients. My point is that the continuing dominance of institutions over formal portraiture invites comparisons between them, which should give us a better understanding of the visual idioms available at any given time. By making several types of comparison – between sitters, artists, men and women, institutions, fields of study and so on – we begin to build up insights into that elusive term *practice*.

PRACTICE

I want now to turn explicitly to this concept, which emphasizes what is done, especially on an everyday basis; practice is the business-as-usual of a given domain. It represents, I suggest, the growing interest of many different kinds of historian in the quotidian processes by means of which cultural products, like social relationships, come into being. Historians of science have been enthusiastic exponents of this trend. They have sought to reveal precisely how kinds of knowledge that can wield considerable authority are made. The end point – a discovery or invention, for instance – comes alive through an analysis of the (social) processes that produced it. Thus the emphasis on practice is also indicative of a desire to reveal the *social* dimensions of these activities, by showing how what was done in science necessarily partook of the larger environment in which it took place. This occurs gradually, to participants even unnoticeably, through customs and habits. When people work in a laboratory, they do not cease to be political or sexual beings, for example. In effect, to insist on the importance of practice and to find creative ways of studying it is to demystify the realm in question, to refuse to treat its achievements with uncritical wonder, and to find it permeated by social forces. This has certainly been the effect of insisting on the importance of practice in the history of science.[8]

The role of the concept in the history of art has been somewhat different.[9] There has long been an interest in what artists do and in the preparatory work that old masters undertook. Thus there has been a traditional and connoisseurial interest in drawing and in preparatory sketches, whatever their medium. This interest has generally been confined to the artistic canon; much less attention has been been paid to amateur drawing or to sketches that were part of occupational activities. The standard art-historical approach is altogether more limited in the way it conceptualizes practice than the one I outlined above. It has been intellectually limited, I would suggest, because of the monetary value attached to the handiwork

of revered artists, which makes questions of attribution and aesthetic appreciation a high priority. I use the word *handiwork* to suggest how strong the interest still is in precisely whose hand was on the canvas. This concern is not new; some Renaissance contracts between artists and their patrons specify exactly who was allowed to actually apply paint to surface.[10] In a studio situation, the work of the master is generally worth a lot more money than that of his assistants and pupils. Attribution is an important issue, but it is only one small aspect of practice. There have been some studies that shed considerable light on studio practice in a more rounded sense, including, for example, questions of how art as a business was managed in the seventeenth and eighteenth centuries. Considerable circumstantial evidence of art practice in its wider sense can be gleaned from diaries and letters, from gossip fortuitously recorded, from memoirs and autobiographies. These are generally snippets that need to be fitted together as one would a jigsaw puzzle. Here I simply want to draw readers' attention to the issues that an emphasis on practice enables us to consider. Some of these have already been mentioned, but it is as well to be explicit about what they are.

We can begin with the particular type of encounter involved in setting up a portrait. I have already stressed the importance of institutions, whether specialized or general educational ones, in commissioning portraits. This involves far more than time and expense. Further pre-conditions include an interest in the displaying and collecting of portraits and the existence of appropriate buildings in which to house them. Although these certainly are architectural issues, they also concern the ways in which buildings are used and experienced on a day-to-day basis. Denys Lasdun's Royal College of Physicians building in Regent's Park, for example, is organized around a central well. On each floor, there are open-sided galleries, which are part of the circulation space around the well; they provide walls on which pictures can be hung. Thus portraits can be seen across the well and on other floors. As a result, much of the College's impressive collection of portraits is seen everyday by

those who work in the building as they go about their daily tasks (illus. 80).[11] By contrast, in most Oxford and Cambridge colleges, although some portraits are displayed in the Hall, where in theory all members of the College may eat, many are kept in rooms frequented by the Fellowship and not by the students.[12] All this implies the existence of practices within such institutions for selecting sitters and artists, for allocating resources to portrait collections, including for conserving and protecting them, and for integrating them into a collective life.

A second set of practices comes into play when the medium and size of the portrait and the artist have been selected, and the two key players encounter each other face to face. What happens next is surely highly variable and depends on the specific historical period, the working methods of the particular artist and the chemistry between the two parties. There are a number of different ways in which these interrelationships can be discussed. We can think, for example, in terms of 'the portrait transaction' – a 'way of conceptualizing portraiture [that] defines identity as an interactive process rather than a revelatory, unifying encounter between opposed figures'.[13] This approach is concerned with subjectivity and is open to the use of psychoanalytic interpretations. Equally, we can see portraiture in terms of social relationships, using in its analysis terms already familiar to cultural and social historians such as 'gender', 'class', 'patron', 'client' and so on. It would also be possible to place particular weight on the economics of the encounter and to consider the contractual relationship, the commission and the work practices of the artist in materialist terms. While this may be thought to reduce culture to issues of money, it is important to remember the material constraints on professional artists, who needed to be practical when it came to achieving a balance between the cost of materials, the time a given work took to produce and the amount they could reasonably charge. It is helpful to give these rather mundane factors some weight in considering the practices of portraiture.

However, as the phrase 'the portrait transaction' suggests, there

80 Interior of the Royal College of Physicians of London, Regent's Park.
The building not only contains numerous walls on which portraits can be hung but also allows them to be viewed from a number of vantage points.

are other, less tangible dimensions to be considered. A thorough-going psychoanalytic account that deployed concepts such as transference and countertransference could explore what goes on between artist and sitter. I would argue that discussions of portrait

practices become stronger as they take more factors into considera-
tion. The fact that two people have a significant meeting, and that
for both their identities are implicated, can scarcely be denied.
Artist's identities are involved because in making images they are
contributing to their reputations and displaying their specialized
skills, in both of which areas they are likely to have consider-
able emotional investment. Sitters' identities are involved because
portraits are visual commentaries on them, expressing something
of what they are/look like and presenting the results to a wider
world. Thus, as I have argued earlier, some concept of identity is
essential when thinking about portraiture in general and about the
social encounters it entails in particular.

Once a portrait is complete, a whole other set of practices
occurs: mounting, framing, copying and transforming into other
media, for example.[14] Then a portrait is likely to be hung, and
commented upon, by patron and client, their friends and associates,
by critics if it goes first into an art exhibition, by users of the room
and building in which it is hung, by art historians and so on. In these
ways, portraits reach into people's lives, are used by them and
turned into forms of discourse. Accordingly, they are commodities,
but they are also cultural resources. They are commodities not just
when they are bought and sold in the usual ways, but when they
are given as gifts or exchanged between members of professional
groupings, a practice that was extremely common in the nineteenth
century. Many scientists and doctors assembled portrait collections,
often mounting them in albums so that they could be experienced
as series of images and as representations of the relationships that
were central to professional life (illus. 81).[15] They are also com-
modities when used as frontispieces or turned into ornaments or
souvenirs. Portraits are cultural resources when they are used to
display achievements, incite emulation, evoke memories, command
respect or allay fear. These two functions – commodities and re-
sources – are not mutually exclusive, but are indicative of two types
of process with which portraiture is bound up.

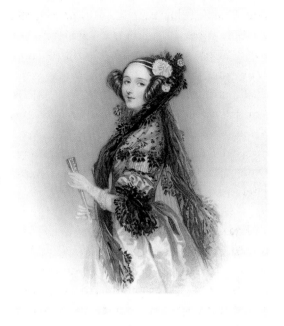

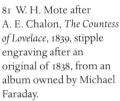

81 W. H. Mote after A. E. Chalon, *The Countess of Lovelace*, 1839, stipple engraving after an original of 1838, from an album owned by Michael Faraday.

Faraday was interested in portraits of fellow scientists and was particularly keen on photography. He pasted images he was given into albums.

I have been suggesting that it is more useful to see portraits as products of social processes than as static objects. Every time we look at a portrait, questions about those processes, even where evidence is fragmentary, should be raised. Generally, evidence about how portraits have been made and used is, to say the least, uneven. However, there are ways of approaching portraiture that are particularly helpful because they either make careful comparisons or suggest special categories of portraits that yield distinctive insights.

SKILLS AND SELVES

In order to pursue this line of thinking a little further, I want to consider briefly the question of who possessed artistic skills outside the ranks of professional artists. Women of a certain class were

expected to acquire skills in drawing and perhaps watercolours. We have already noted that Mary Somerville received such instruction; she became a competent artist to the degree that one image of her has been taken to be a self-portrait (illus. 82). Unless there is independent evidence, it is hard to assess such claims with any degree of confidence, and it has been said that it is doubtful whether this work is in fact by her own hand.[16] In a sense, this matters less than the point about the prevalence of drawing skills. There have been two categories of practitioners of science, medicine and technology in which artistic skills were both common and valued. The first was medicine, where many practitioners were able and encouraged to draw anatomical subjects. Drawings provided useful records and aides-mémoires. Some medical men, such as John Bell and his brother Sir Charles Bell, were extremely skilled artists, producing drawings and, in John's case, prints for publication (illus. 83).[17] The second category was in the broad area of natural history, where an ability to sketch what was observed in the field was particularly useful. The practice of employing specialized artists to undertake such work was more or less routine by the eighteenth century, when voyages undertaken with the idea of acquiring knowledge often included an artist among the ship's company. The use of such specialized artists did not mean that naturalists stopped drawing themselves; many scientists sketched routinely, and some continue to do so. There are, for example, a number of field notebooks that belonged to nineteenth-century geologists, and many who undertook laboratory work produced sketches of apparatus, microscope slides or the results of their research.[18]

We can briefly consider four specific examples to illustrate these points about skills. William Stukeley is described in the *Dictionary of National Biography* as an 'antiquary', but he was also a medical practitioner who studied with Richard Mead in 1709. His wash drawing of Mead is dated 1725 (illus. 84). Stukeley lived in London from 1709 until 1726, during which time he became a Fellow of both the Royal Society and the College of Physicians as well as a friend of Sir Isaac

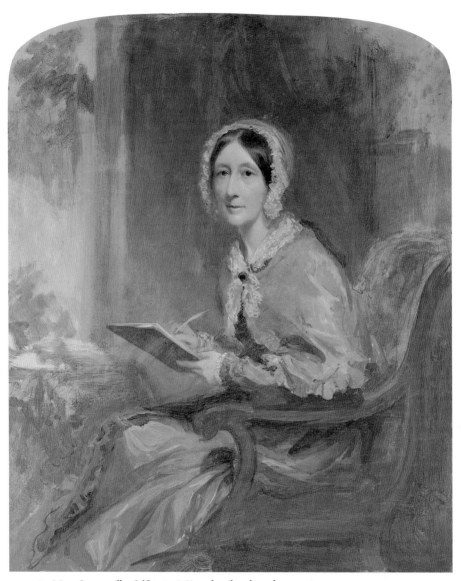

82 Mary Somerville, *Self-portrait* (?), n.d., oil on board, 45.7 × 61 cm.

83 J. Stewart after John Bell, *Arm of Charles Challoner, Marine*, c. 1826, coloured stipple engraving.

John Bell was a Scottish surgeon and, like his brother Charles, a good artist. He produced many sets of anatomical illustrations, including *Engravings Explaining the Anatomy of the Bones, Muscles and Joints* (1794).

Newton's, just like Mead, with whom he shared a further interest in coins and medals. I have not seen any discussion of the circumstances surrounding the production of this portrait, but it seems reasonable to attribute its existence to the fact that the two men moved in the same circles and had many interests in common. We also know that Stukeley made drawings of his coin collection. The image of Mead is competent rather than artistically brilliant; its interest lies in its being an expression of a particular kind of intellectual, professional and social contact between two people within scientific and medical communities.[19]

The type of social engagement in the next example could not be more different. Lady Byron, born Annabella Milbanke, drew her daughter Ada Lovelace as she lay dying of uterine cancer while still in her 30s (illus. 85; compare illus. 81). Lady Byron was herself an intellectual woman, whose interests included mathematics and whose friends included the actress Sarah Siddons and the novelist Maria Edgeworth. Her bizarre and disastrous marriage to Lord Byron produced a daughter, Augusta Ada, who took Mary Somerville as

her model and mentor and became a mathematician. Ada Lovelace (her husband was created Viscount Lovelace in 1835) is particularly associated with Charles Babbage, the 'computer pioneer'. As one recent commentator put it: '. . . by 1852 she was in serious pain and her death chamber was the scene of a drama presided over by her vulturine mother.'[20] Ada Lovelace was indeed at the centre of conflicts between those closest to her, and one of the most contentious issues was her management of her self and her passion for mathematics in the light of her physical fragility. Deathbed sketches were not uncommon, but this one is of particular interest given that it is of a daughter by a mother, and that it depicts a woman who described herself as a 'bride of science', but whose intellectual ambitions were thwarted. Like Mary Somerville, who gave her tutorials, Lovelace is

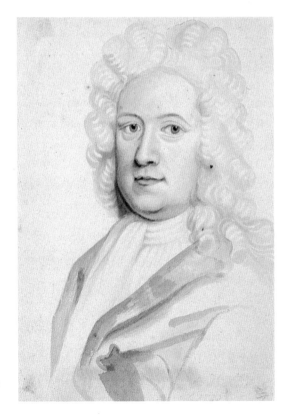

84 William Stukeley, *Richard Mead*, 1725, wash on paper, 22 × 15.2 cm.

147

85 Lady Byron, Sketch of Ada Lovelace on her deathbed, 1852.
It remains extraordinarily hard to either reconstruct or fully understand the motives behind the making of such an image – tender recollection, a way of managing grief, a final record?

presented as an expositor of science rather than an original scientific researcher in her own right. It is probably dangerous to speculate about her mother's motivation for making the sketch, which should rather be used as an occasion for reflection on the social circumstances that generate portraits.

I have stressed that artistic skills were fairly common in the scientific and medical communities. A neat illustration of this point is the geologist Sir Henry de la Beche (illus. 86).[21] His competence at sketching was sufficiently noteworthy to be mentioned in the *Dictionary of National Biography* entry on him, and he was also a mapmaker. There are many sketches among his papers, including caricatures, but one is of special relevance to the themes of this chapter (illus. 87). It has been called a 'self-sketch', and in it de la Beche depicted himself sitting in his lodgings in Cornwall during a visit in January 1837. The sketch was drawn for his daughter to show his disappointment at being unable to be outdoors because of heavy rain. It contains a number of accoutrements: hammer, cloak and hat, map case and compass. De la Beche was a major figure in

86 T. H. Maguire, *Sir Henry Thomas de la Beche*, 1851, lithograph, 28.8 × 23.9 cm.

geological circles who undertook a great deal of what could be called public-service work in his surveying activities. He received many honours; the knighthood came in 1848. The value of the 'self-sketch' is the glimpse it gives of his sense of himself and of his scientific activities and the way it reveals sketching to have been integral to his working life (compare illus. 88). Little research has been undertaken on the self-portraits of scientists and medical men, which seem to be rather rare, perhaps surprisingly so given the ubiquity of artistic skills.

We can compare de la Beche's playful drawing with an altogether more intense self-portrait. Clive Riviere painted himself in 1925 when he was in his early 50s; he died just four years later (illus. 89). His father was a Royal Academician who specialized in painting animals, so art and careful observation were integral to his life. The

87 Letter from Henry de la
Beche to his daughter Bessie,
12 January 1837.

88 Letter from Henry de la Beche to Adam Sedgwick, December 1834.
Embedded within a letter to the distinguished Cambridge geologist Adam Sedgwick,
de la Beche produced a sharp commentary on clashing scientific styles.

89 Clive Riviere, *Self-portrait*, 1925, oil sketch, 25.5 × 35.8 cm (irregular).
Riviere was seen as sensitive and artistic. In medical circles, these traits were presented in terms of the fine clinical judgement that helped him in treating thoracic disease.

entire picture is taken up by his head; he stares at the viewer through spectacles, and there is no sense at all of his chosen occupation (he was a chest physician).[22] A photograph of him, its date unfortunately unknown, gives a similar impression, and this distinctive style remains common in his portraits, even those intended for professional purposes (illus. 90). The circumstances of Riviere's self-portrait remain obscure, but the image should prompt us to reflect on both the drive to produce artworks among medical practitioners and their chosen idioms. It is essential to remember that biographical information about a sitter is not necessarily conveyed visually. Viewers are expected to work to supplement their visual experience; they do so using knowledge that has been gleaned from texts, other images and more casual sources such as newspapers and gossip. Equally, viewers draw on contexts, especially those of institutions, as a further supplement. On occasion, it may also be possible to use

90 Elliot & Fry, *Clive Riviere*, photograph.
Unfortunately, little is known about this photograph, which possesses some of the same intensity as the self-portrait shown in illus. 89, although Riviere looks considerably younger here.

aspects of the portrait itself – for example, its size and frame and the pose of the sitter – to provide further clues. These are skills in responding to portraits that many people have without being aware of them; they are just as indicative of social processes as are the details of commissions and the display of portraits in series.

I have been suggesting that for many types of scientist and doctor, artistic skills were part of what they did, and that sometimes they turned them to portraiture. Science, medicine and technology are certainly intellectual activities, but the degree to which they are also visual is often missed by those with no first-hand experience of them. Practical skills that frequently demand a high level of visual acuity are also involved. Visual skills, like other practices of daily life, make a major contribution to a person's sense of self; skills and selves are closely related. Clearly 'work', defined as broadly as possible to include, for instance, the gentlemanly practice of science, is

central to an individual's identity and, despite the existence of potent stereotypes, can be expressed pictorially in diverse ways, even at a given place and time. Thus one aim of this chapter is to draw attention not only to the diverse practices that portraiture involves but also to the range of available visual idioms. The result is that choices are constantly being made about every aspect of a portrait, although they are not necessarily undertaken in a fully conscious fashion. This is just one approach that can be taken towards the processes of portraiture; another is to focus on the specifically artistic processes.

SKETCHES

As I have already made clear, I have no interest in an approach to sketches that presents them as precious remnants of a master at work. But if they afford us insights into the particular kinds of problem-solving that portraiture involves, they become altogether more interesting. The difficulty is finding suitable materials. I would like briefly to discuss a particular example to see what light drawing can shed on our concerns with the depiction of specific groups of people. And I would like to come at the sketch in question – Henry Moore's drawing of Dorothy Hodgkin's hands – by considering other images of her first.

Without doubt, Dorothy Hodgkin is an exceptionally important figure in the development of twentieth-century British science, and her memory is actively maintained in a number of ways that serve to keep her symbolic significance alive (illus. 23). The Royal Society, of which she became a Fellow in 1947 at the age of 37, has created a special fellowship scheme, named in her honour, to help women who wish both to be career scientists and to raise children. Her old college – appropriately enough, Somerville College, Oxford – is also active in keeping her memory alive; it is possible, for example, for alumni to purchase a small replica head of her. A full biography of her has recently been published.[23] The Royal Society, like the

91 Maggi Hambling, *Dorothy Hodgkin*, 1985, oil on canvas, 93.2 × 76 cm.

National Portrait Gallery, owns important images of her. Undoubt-edly, the portrait that has reached the widest audience is that by Maggi Hambling, painted in 1985 when its subject was 75 (illus. 91, 92). Hodgkin is shown at work in a domestic setting, a sandwich mixed in with the papers. Although this is a memorable image of her, her body in fact takes up a relatively small proportion of the canvas. Two other features stand out: the large molecular model and her hands, of which there are four. This produces a sensation of movement, but they are just as striking in their gnarled appearance. Hodgkin started to have problems with rheumatoid arthritis when she was only 28. Manual dexterity was, especially in her early years as a scientist, absolutely essential, and her biographer makes clear how very important her persistence was in solving practical problems.

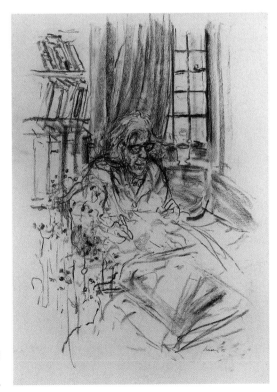

92 Maggi Hambling, *Dorothy Hodgkin* (preparatory drawing), 1985, charcoal on paper, 76.2 × 55.8 cm. Collection of the artist.
 This powerful drawing is recognizably related to the final version (illus. 91).

It was Hambling's decision to paint her at work, and the artist was struck by Hodgkin's intense concentration, which involved a combination of physical movement and quiet focus. The hands, according to Hambling, 'happened in the painting'.[24]

Hambling's canvas is, in the best sense of the word, sketchy. This is not just because the hands convey the idea that Hodgkin was actually being a scientist as the picture was being painted, which is rare in scientific portraiture, but also because the way in which the paint was applied – to show the uprights of the models, for example – looks unfinished. With these points in mind, we can consider Henry Moore's drawing of Hodgkin's hands, produced in 1978 and presented to the Royal Society the following year (illus. 93). Moore had met Hodgkin many years previously; when invited to produce a portrait he declined, offering to draw her hands instead. His

93 Henry Moore, *Dorothy Hodgkin's hands*, 1978, drawing, 24 × 30 cm.

94 Anonymous bronze cast of the right hand of Harvey Cushing, 1922.
As practitioners who rely on manual dexterity, surgeons have placed
a high value on their hands. This is evident here, in the fact of giving
permanent form to the hand of a noted practitioner of surgery.

attentiveness to them is noteworthy. This beautiful drawing is
certainly not a study of abnormality, but an exploration of form.
Is it a portrait? Hodgkin's hands are quite noticeable in many
photographs of her, but someone without prior knowledge would
hardly be able to identify her from them. In fact, this applies to faces
too – independent knowledge of some kind is invariably required,
if only from a label, to identify sitters with any accuracy. (Very few
scientists are instantly recognized by the general public.) By conven-
tion, the face has for centuries been given a special status – as Cicero
put it, the face is the mirror of the soul. So, in a distinctive way, have
hands acquired special status, with their capacity for expression and

their ability to carry out the wishes of the mind.[25] That dexterity is exceptionally valued in the practice of science, medicine and technology should not be surprising, and the degree to which it has been prized is evident from the casts of the hands of practitioners in the collections of the Royal College of Surgeons in London (illus. 94).

In Moore's case, a drawing was not a preparation for something else, but an entire way of thinking about, looking at and responding to the worlds around him.[26] Sketches can therefore be a form of representation in their own right, one used to exceptional effect by Moore throughout his life and deployed by Hambling to convey something quite specific about Hodgkin's life work. In both cases, there is an intimate blending between visual characteristics and features of the sitter's life and work that makes the final image unusually satisfying. However, many sketches are preparatory studies and are routinely used by art historians to reconstruct working methods. As it happens, the Royal Society also owns a preparatory sketch for another portrait of Hodgkin, by Graham Sutherland, a portrait left uncompleted at the time of the artist's death in 1980 (illus. 95). Over her life, Hodgkin received a great deal of visual attention. Commentators often noted her personal charms; her recent biography similarly emphasizes how attractive she was – an old trope in writing about women who distinguish themselves in areas strongly coded as masculine. Perhaps the images by Moore and Hambling stand out because they take such different routes, both emphasizing a part of Hodgkin's body that was *not* conventionally attractive and that gave her considerable pain.

I want to see working methods as processes in which choices are made about the best visual idiom to use in a given situation. By 'best', I mean visually pleasing for the artist and for viewers, although the success of any image must be considered relative to prevailing aesthetic frameworks and personal taste. But I also mean socially apt – taking account of the sitter's situation in the fullest sense. So 'artistry' is about picking up not only on important aspects of sitters themselves, but on issues within their chosen fields and on

95 Graham Sutherland, *Dorothy Hodgkin*, 1980, watercolour.
There is often something rather poignant about an uncompleted picture, especially when the reason is the artist's death. Sutherland's working methods are clearly visible in this instance.

public perceptions and anxieties. There can be no better example of this point than Allan Ramsay's portrait of his friend and fellow Scot William Hunter, probably painted in the mid-1760s (illus. 96). Hunter was extremely fond of the work of the French artist Jean-Baptiste-Siméon Chardin and eventually owned three fine canvases by him, which hang, together with Ramsay's portrait of their owner, in the Hunterian Art Gallery in Glasgow. Commentators have remarked on the Chardinesque qualities of Ramsay's portrait.[27] Many preparatory studies exist for his magnificent portrait oeuvre, including a black-and-white chalk sketch for the likeness of Hunter (illus. 97). It closely resembles the final canvas, although there are some small differences. But the problem-solving has already occurred. Hunter is seated sideways to his viewers, but turns to face them. His arms rest on a table; he holds some paper. This is an extremely simple composition, and therein lies its cleverness. Hunter is not presented as a member of two controversial occupations (he

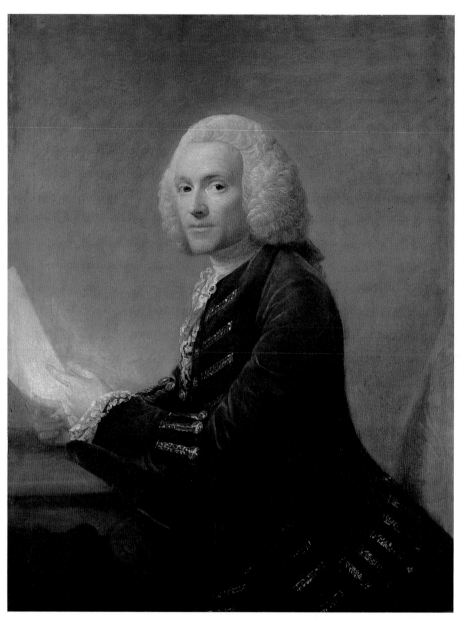

96 Allan Ramsay, *William Hunter*, *c.* 1764, oil on canvas, 95.9 × 74.9 cm.

97 Allan Ramsay,
William Hunter, c. 1758,
black chalk heightened
with white on dark blue
paper, 40.5 × 30.4 cm.

trained as a surgeon and practised man-midwifery as well as
anatomy). He is a member of polite society, details unspecified.
Note that in the finished canvas, the paper is blank, its creamy, glow-
ing surface a source of light. The attire is simple but elegant. I would
argue that much of the cultural work of the picture derives from its
colour scheme: the soft grey-blue of the background, the deeper
blue of the coat. In this respect, the sketch reveals, if I can put it this
way, how Ramsay was thinking about the structure of the picture,
but not how texture and colour – which are central to the overall
effect – were to be used. Ramsay was an outstanding painter of
fabrics, which are particularly breathtaking in his portraits of
women. Yet, here the detail of the plain fabric is far from virtuosic,
the lace and braid are sketchily evoked, the folds of the jacket are
visually effective but not at all elaborate. In its own way, it is as
brilliant a solution to the problem of depicting a controversial and

98 Tom Phillips, Preparatory work for portrait of Professor Susan Greenfield, 1999, pen on paper, 29.3 × 21 cm.

While not a sketch in the conventional sense, this sheet shows Phillips working with visual ideas generated by Greenfield's personality and interests: she has a high media profile and works on the brain.

upwardly-mobile medical man as Joshua Reynolds's portrait of his brother John was two decades later (illus. 69).

I have argued that the worlds of science, medicine and technology have offered distinctive challenges to those who have portrayed their notable practitioners (illus. 98). There has been a huge variety of visual responses to these challenges. This is neither paradoxical nor contradictory but a feature of many, if not most, types of portraiture, which respond to highly specific situations, sometimes in strikingly inventive ways. Nevertheless, they pretty much have to do so in a manner that will be recognizable to broad audiences. This is one of the reasons why accoutrements have had a long life in portraits – they convey information in a conventionalized form, which the body of the sitter does not then have to carry. Naturally, the objects themselves must possess a degree of cultural trans-parency. Over the centuries, objects and their associations inevitably have changed, and so have presuppositions about how artworks should carry their meanings. Twentieth-century portraits of scien-tists, doctors and technologists may well include significant objects, but for the most part we expect these to be plausibly integrated with their settings. An accoutrement *out* of its setting jars partly because it has become accepted over the last 150 years or so that scientists and doctors *can* be shown either *at* work or *in* their place of work. In practice, these places have become more clearly delineated from other spaces, especially domestic ones, over the same period.

But many portraits, in these spheres as in others, work without any additional clues at all. Sometimes, a face becomes so familiar that it can effect a tremendous amount of cultural business without further supplements, but in the areas we have been considering, this phenomenon is extremely rare. It has happened with a tiny number of twentieth-century scientists who have had high media profiles. Scientific and medical portraits tend either to be viewed in quite specific contexts, such as specialized institutions, or to function in a wider world but with textual supplements. People often ask what

is special about scientific and medical portraits; there can be no simple, overall answer to such a question. All we can do is to chart some of the cultural manoeuvrings case by case, period by period. The important point remains that portraits are exceptionally rich sources for cultural history. They allow us to think, for example, about the relationships between science, medicine and technology and their publics. Portraits do indeed afford privileged insights, but not into what people in the past were 'really' like. They can only offer such insights when placed in context and interpreted in the light of other sources. Portraits are frozen moments of elaborate processes; as such, they reveal social negotiations, not individual character. Given their growing dominance in our culture since the seventeenth century, there are no domains whose social and human dimensions require more urgent understanding than science, medicine and technology. Portraits offer one way in, a way that delights the senses as it stimulates us to think more openly and critically about those who create natural knowledge.

REFERENCES

I INTRODUCING PORTRAITURE

1 In preparing this book, I have drawn extensively on the holdings of the
 Wellcome Institute Library in London and would like to thank the staff
 there for their kind help. Useful works on portraiture in general include
 R. Brilliant, *Portraiture* (London, 1991); J. Woodall, ed., *Portraiture: Facing
 the Subject* (Manchester, 1997); M. Pointon, *Hanging the Head: Portraiture
 and Social Formation in Eighteenth-Century England* (New Haven and
 London, 1993). Relatively little has been published specifically on portraits
 of scientists and doctors; see, for example, W. Hackmann, *Apples to
 Atoms: Portraits of Scientists from Newton to Rutherford* (London, 1986);
 B. Brame Fortune and D. J. Warner, *Franklin and His Friends: Portraying
 the Man of Science in Eighteenth-Century America* (Washington and
 Philadelphia, 1999). The catalogues produced by institutions with portrait
 collections are helpful; when relevant, these are cited throughout this
 volume.
 Any work on portraiture depends on biographical insights regarding
 sitters and artists. I have relied heavily on the *Dictionary of National
 Biography*, partly because it often mentions portraits and social contacts.
 However, I have not cited each entry individually in my references, nor
 have I attributed information from standard biographical dictionaries
 unless there is a direct quotation. Finally, although I have tried to avoid
 the anachronistic use of 'science' and 'scientist', it has sometimes been
 unavoidable for the sake of brevity – the context of such use should make
 my meaning plain.

2 On portraits as art, see the works by Brilliant, Woodall and Pointon cited
 above, and also N. Schneider, *The Art of the Portrait* (Cologne, 1994);
 S. Koerner, *The Moment of Self-portraiture in German Renaissance Art*
 (Chicago, 1993); S. West, 'Portraiture: Likeness and Identity', in S. West,
 ed., *Guide to Art* (London, 1996), pp. 70–83.

3 G. Clarke, ed., *The Portrait in Photography* (London, 1992).

4 M. Tabor, *Pioneer Women Fourth Series* (London, 1933); C. Lubbock, ed.,
 *The Herschel Chronicle: The Life-Story of William Herschel and His Sister
 Caroline Herschel* (London, 1933); H. Ashton and K. Davies, *I Had a Sister:*

A Study of Mary Lamb, Dorothy Wordsworth, Caroline Herschel, Cassandra Austen (London, [1937]).

5 On notions regarding 'public', see, C. Calhoun, ed., *Habermas and the Public Sphere* (Cambridge, MA, 1992); J. Elshtain, *Public Man, Private Woman: Women in Social and Political Thought* (Oxford, 1981); S. Shapin, 'Science and the Public', in R. Olby *et al.*, eds, *Companion to the History of Modern Science* (London and New York, 1990), pp. 990–1007; L. Stewart, *The Rise of Public Science: Rhetoric, Technology and Natural Philosophy in Newtonian Britain 1660–1750* (Cambridge, 1992).

6 A. Smart, *Allan Ramsay: Painter, Essayist and Man of the Enlightenment* (New Haven and London, 1992); A. Gunther, *An Introduction to the Life of the Rev. Thomas Birch* (Halesworth, Suffolk, 1984); B. Nicolson, *The Treasures of the Foundling Hospital* (London, 1972); R. McClure, *Coram's Children: The London Foundling Hospital in the Eighteenth Century* (New Haven and London, 1981).

7 Smart, *Allan Ramsay*, pp. 65–7; Gunther, *An Introduction*, esp. p. 33, which lists the members of the club. Coram was also a member.

8 D. Bindman and M. Baker, *Roubiliac and the Eighteenth-Century Monument: Sculpture as Theatre* (New Haven and London, 1995); J. Moore, 'Charles Darwin Lies in Westminster Abbey', in R. Berry, ed., *Charles Darwin: A Commemoration 1882–1982* (London, 1982), pp. 97–113; J. Moore, *The Darwin Legend* (Grand Rapids, MI, 1994); C. Wilson *et al.*, *The New Bell's Cathedral Guides: Westminster Abbey* (London, 1986); P. Burman, *The New Bell's Cathedral Guides: St Paul's Cathedral* (London, 1987); A. Hall, *The Abbey Scientists* (London, 1966); F. Haskell, 'The Apotheosis of Newton in Art', in *Past and Present in Art and Taste* (New Haven and London, 1987), pp. 1–15, 227–8.

9 J. Brooke, *Science and Religion: Some Historical Perspectives* (Cambridge, 1991).

10 P. Barlow, 'Facing the Past and Present: The National Portrait Gallery and the Search for "Authentic" Portraiture', in Woodall, ed., *Portraiture*, pp. 219–38.

11 The copies and derivatives of Reynolds's portrait of John Hunter are particularly interesting; see Hackmann, *Apples to Atoms*, pp. 31–2 on Jackson's copy. For prints based on the image, see R. Burgess, *Portraits of Doctors and Scientists in the Wellcome Institute of the History of Medicine* (London, 1973), pp. 179–80.

12 D. Fox and C. Lawrence, *Photographing Medicine: Images and Power in Britain and America since 1840* (New York and London, 1988).

13 Fortune and Warner, *Franklin and His Friends*, esp. chaps 3, 4. Compare C. Lawrence and S. Shapin, eds, *Science Incarnate: Historical Embodiments of Natural Knowledge* (Chicago, 1998).

14 On the trope of melancholy, see L. Jordanova, *Nature Displayed: Gender, Science and Medicine 1760–1820* (Harlow, Essex, 1999), chap. 4.

15 Hackmann, *From Apples to Atoms*, pp. 33–4; Burgess, *Portraits of Doctors and Scientists*, p. 384; Henry, Lord Brougham, *Lives of Men of Letters and Science, who flourished in the Times of George III*, 2 vols (London, 1845–6); G. Wiliamson, *Memorials of the Lineage, Early Life, Education, and Development of the Genius of James Watt* (Edinburgh, 1856).

16 C. Webster, *The Great Instauration: Science, Medicine and Reform, 1626–1660* (London, 1975); J. Martin, *Francis Bacon, the State, and the Reform of Natural Philosophy* (Cambridge, 1982). On the Royal Society, see T. Sprat, *History of the Royal Society* (1667; St Louis and London, 1959); M. Hall, *All Scientists Now: The Royal Society in the Nineteenth Century* (Cambridge, 1984).

17 The picture, by Zoffany, is reproduced in J. Abrams, *Lettsom: His Life, Times, Friends and Descendants* (London, 1933), p. 449.

18 W. Schupbach's *The Paradox of Rembrandt's 'Anatomy of Dr. Tulp'* (London, 1982) is an outstanding piece of scholarship on the Rembrandt painting.

19 M. Webster, *Johan Zoffany 1733–1810* (London, 1976), esp. pp. 57–8; I. Bignamini and M. Postle, *The Artist's Model: Its Role in British Art from Lely to Etty* (Nottingham, 1991), esp. pp. 25–7, 32, 38–43, 85, 87.

20 Details of the *Men of Science* image may be found in R. Walker, *Regency Portraits* (London, 1985), vol. I, pp. 605–8; vol. II, pls 1516–24. On the print, see A. Clow, 'A Re-examination of William Walker's "Distinguished Men of Science"', *Annals of Science*, 11 (1956), pp. 183–93; L. Jordanova, 'Science and Nationhood: Cultures of Imagined Communities', in G. Cubitt, ed., *Imagining Nations* (Manchester, 1998), pp. 194–211, esp. 194–6.

II BOUNDARIES

1 R. Williams, *Keywords: A Vocabulary of Culture and Society*, rev. edn (London, 1983); P. Corfield, ed., *Language, History and Class* (Oxford, 1991).

2 On the issue of cultural continuities, see, for example, R.J.J. Martin, 'Explaining John Friend's *History of Physick*', *Studies in History and Philosophy of Science*, 19 (1988), pp. 399–418; L. Jordanova, *The Sense of a Past in Eighteenth-Century Medicine* (1997 Stenton Lecture) (Reading, 1999).

3 T. Pinch, 'The Sociology of the Scientific Community', and J. Morrell, 'Professionalisation', in R. Olby *et al.*, eds, *Companion to the History of Modern Science* (London, 1990), pp. 87–99, 980–89; M. Rossiter, *Women Scientists in America: Struggles and Strategies to 1940* (Baltimore, 1982); E. Riska and K. Wegar, eds, *Gender, Work and Medicine: Women and the Medical Division of Labour* (London, 1993).

4 T. Johnson, *Professions and Power* (London, 1972); E. Freidson, *Profession of*

Medicine (New York, 1970); N. and J. Parry, *The Rise of the Medical Profession: A Study of Collective Social Mobility* (London, 1976); Morrell, 'Professionalisation'; T. Gelfand, 'The History of the Medical Profession', in W. Bynum and R. Porter, eds, *Companion Encyclopedia of the History of Medicine* (London, 1993), pp. 1119–50; R. Kargon, *Science in Victorian Manchester: Enterprise and Expertise* (Manchester, 1977); I. Varcoe, M. McNeil and S. Yearley, eds, *Deciphering Science and Technology: The Social Relations of Expertise* (Basingstoke and London, 1990).

5 R. Porter, *Health for Sale: Quackery in England, 1660–1850* (Manchester, 1989).

6 On John Harrison, see D. Sobel, *Longitude* (New York, 1995), and (with W. Andrews) *The Illustrated Longitude* (London, 1998), esp. chap. 12 on portraits. Both versions have as their subtitle 'The True Story of a Lone Genius Who Solved the Greatest Scientific Problem of His Time', which neatly encapsulates the book's romanticizing approach. On 'technology' and its relations with 'science', see D. Cardwell, *Technology, Science and History: A Short Study of the Major Developments in the History of Western Mechanical Technology and Their Relationships with Science and Other Forms of Knowledge* (London, 1972); G. Basalla, *The Evolution of Technology* (Cambridge, 1988), chap. 2.

7 J. Lane, *Apprenticeship in England, 1600–1914* (London, 1996).

8 J. Morrell, *Science at Oxford 1914–1939: Transforming an Arts University* (Oxford, 1997); L. Rosner, *Medical Education in the Age of Improvement: Edinburgh Students and Apprentices 1760–1826* (Edinburgh, 1991); J. Gascoigne, *Cambridge in the Age of the Enlightenment: Science, Religion and Politics from the Restoration to the French Revolution* (Cambridge, 1989); L. Stone, ed., *The University in Society*, 2 vols (Princeton, 1980).

9 Letters provide good raw material for reconstructing networks and patterns of sociability. See, for example, J. Morrell and A. Thackray, eds, *Gentlemen of Science: Early Correspondence of the British Association for the Advancement of Science* (London, 1984); B. Corner and C. Booth, eds, *Chain of Friendship: Selected Letters of Dr. John Fothergill of London, 1735–1780* (Cambridge, MA, 1971); A. R. Hall and M. B. Hall, eds, *The Correspondence of Henry Oldenburg*, 13 vols (London and Philadelphia, 1965–86).

10 G. Ferry, *Dorothy Hodgkin: A Life* (London, 1998), esp. chaps 2–4.

11 W. Bynum and R. Porter, eds, *William Hunter and the Eighteenth-Century Medical World* (Cambridge, 1985); I. Pears, *The Discovery of Painting: The Growth of Interest in the Arts in England 1680–1768* (New Haven and London, 1988); M. Webster, 'Taste of an Augustan Collector: The Collection of Dr. Richard Mead', *Country Life*, 29 January 1970, pp. 249–51; 24 September 1970, pp. 765–7.

12 M. McNeil, *Under the Banner of Science: Erasmus Darwin and His Age*
 (Manchester, 1987); D. King-Hele, ed., *The Letters of Erasmus Darwin*
 (Cambridge, 1981); R. Schofield, *The Lunar Society of Birmingham: A Social
 History of Provincial Science and Industry in Eighteenth-Century England*
 (Oxford, 1963); G. Williamson, *Memorials of the Lineage, Early Life,
 Education, and Development of the Genius of James Watt* (Edinburgh, 1856).

13 'Discovery' can be a problematic idea. Since the term implies innovation
 and originality, which are highly valued, it is often loaded. Over the last
 two hundred years, there has been considerable concern, among both
 practitioners and the public, about priority disputes, and in the process
 the names of discoverers have been used as tags to link individuals with
 specific achievements. These have become sites of considerable conflict
 within the scientific, medical and technological communities.

14 G. Wolstenholme, ed., *The Royal College of Physicians of London: Portraits*
 (London, 1964); *idem* and J. Kerslake, *The Royal College of Physicians of
 London: Portraits Catalogue II* (Amsterdam, 1977); G. Clark, *A History of the
 Royal College of Physicians of London*, 2 vols (Oxford 1964–6).

15 S. Jacyna, 'Images of John Hunter in the Nineteenth Century', *History of
 Science*, 11 (1983), pp. 85–108; W. LeFanu, *A Catalogue of the Portraits and
 Other Paintings, Drawings and Sculpture in the Royal College of Surgeons of
 England* (Edinburgh and London, 1960) (Reynolds's portrait of John
 Hunter is used as the frontispiece).

16 A recent example is M. Bragg, *On Giants' Shoulders: Great Scientists and
 their Discoveries from Archimedes to DNA* (London, 1998).

17 On Nightingale, see M. Baly, *Florence Nightingale and the Nursing Legacy*
 (London, 1988); F. Smith, *Florence Nightingale: Reputation and Power*
 (London, 1982); M. Vicinus, '"Tactful Organising and Executive Power":
 Biographies of Florence Nightingale for Girls', in M. Shortland and
 R. Yeo, eds, *Telling Lives in Science* (Cambridge, 1996), pp. 195–214.

18 S. Shapin, '"A Scholar and a Gentleman": The Problematic Identity of the
 Scientific Practitioner in Early Modern England', *History of Science*, 29
 (1991), pp. 279–327, n. 74 cites further items on gentlemanliness and the
 Royal Society. For the nineteenth century, see J. Morrell and A. Thackray,
 *Gentlemen of Science: Early Years of the British Association for the
 Advancement of Science* (Oxford, 1981).

19 R. Porter, 'Gentlemen and Geology: The Emergence of a Scientific
 Career, 1660–1920', *Historical Journal*, 21 (1978), pp. 809–36; M. Rudwick,
 *The Great Devonian Controversy: The Shaping of Scientific Knowledge among
 Gentlemanly Specialists* (Chicago, 1985).

20 Roy Porter's writings have done a great deal to disseminate ideas about a
 medical marketplace; see, for example, R. Porter, ed., *Patients and*

Practitioners: Lay Perceptions of Medicine in Pre-Industrial Society
(Cambridge, 1985); R. Porter, ed., *The Medical History of Waters and Spas*
(London, 1990); R. Porter, *Doctor of Society: Thomas Beddoes and the Sick
Trade in Late-Enlightenment England* (London, 1992).

21 L. Hunter and S. Hutton, eds, *Women, Science and Medicine 1500–1700:
Mothers and Sisters of the Royal Society* (Stroud, 1997); L. Shiebinger, *The
Mind Has No Sex? Women in the Origins of Modern Science* (Cambridge, MA,
1989); P. Abir-Am and D. Outram, eds, *Uneasy Careers and Intimate Lives:
Women in Science, 1789–1979* (New Brunswick, NJ, 1987); M. Rossiter, *Women
Scientists in America: Struggles and Strategies to 1940* (Baltimore, 1982).

22 Relevant studies include J. Gascoigne, *Science in the Service of Empire:
Joseph Banks, the British State and the Uses of Science in the Age of Revolution*
(Cambridge, 1998); R. Stafford, *Scientist of Empire: Sir Robert Murchison,
Scientific Exploration and Victorian Imperialism* (Cambridge, 1989);
T. Porter, *Trust in Numbers: The Pursuit of Objectivity in Science and Public
Life* (Princeton, 1995); J. Crowther, *Statesmen of Science* (London, 1965).

23 S. Bann, ed., *Frankenstein, Creation and Monstrosity* (London, 1994).

24 J. Wilmerding, ed., *Thomas Eakins (1844–1916) and the Heart of American
Life* (London, 1993), pp. 28–9, 128–33; E. Johns, *Thomas Eakins: The Heroism
of Modern Life* (Princeton, 1983).

III GENDER AND SCIENTIFIC HEROISM

1 R. Fisher, *Edward Jenner 1749–1823* (London, 1991); J. Baron, *The Life of
Edward Jenner* (London, 1827); [W. MacMichael], *Lives of British Physicians*
(London, 1830); W. LeFanu, *A Bio-bibliography of Edward Jenner, 1749–1823*
(London, 1951); E. Underwood and A. Campbell, *Edward Jenner: The Man
and His Work* (Bristol, 1967).

2 This special lineage is the subject of the account of its owners written in
the voice of a cane in the Royal College of Physicians: [W. MacMichael],
The Gold-Headed Cane (London, 1827, and many subsequent editions).

3 W. Bynum and R. Porter, eds, *William Hunter and the Eighteenth-century
Medical World* (Cambridge, 1985); C. H. Brock, ed., *William Hunter
1718–1783* (Glasgow, 1983) and 'The Many Facets of Dr. William Hunter
(1718–83)', *History of Science*, 32 (1994), pp. 387–408.

4 D. Hopkins, *Princes and Peasants: Smallpox in History* (Chicago and
London, 1983); P. Razzell, *The Conquest of Smallpox: The Impact of
Inoculation on Smallpox Mortality in Eighteenth Century Britain* (Firle, 1977);
F. Fenner *et al.*, *Smallpox and Its Eradication* (Geneva, 1988); D. Baxby,
Jenner's Smallpox Vaccine: The Riddle of Vaccinia Virus and Its Origin
(London, 1981).

5 J. Favel *et al.*, eds, *Let Newton Be! A New Perspective on His Life and Works* (Oxford, 1988); R. Westfall, *Never at Rest: A Biography of Isaac Newton* (Cambridge, 1980); M. Jacob, *The Newtonians and the English Revolution 1689–1720* (Ithaca, NY, 1976).

6 S. Smiles, *Lives of Boulton and Watt* (London, 1865); L. Rolt, *James Watt* (London, 1962); C. MacLeod, 'James Watt, Heroic Invention and the Idea of the Industrial Revolution', in M. Berg and K. Bruland, eds, *Technological Revolutions in Europe* (Cheltenham, 1998), pp. 96–116. See also L. Jordanova, 'Science and Nationhood: Cultures of Imagined Communities', in G. Cubitt, ed., *Imagining Nations* (Manchester, 1998), pp. 192–211.

7 See, for example, G. Smith, 'Prescribing the Rules of Health: Self-help and Advice in the Late Eighteenth Century', in R. Porter, ed., *Patients and Practitioners* (Cambridge, 1985), pp. 249–82; J. Riley, *The Eighteenth-century Campaign to Avoid Disease* (Basingstoke and London, 1987); A. Wear, 'The History of Personal Hygiene', in W. Bynum and R. Porter, eds, *Companion Encyclopedia of the History of Medicine* (London and New York, 1993), pp. 1283–1308.

8 G. Miller, *The Adoption of Inoculation for Smallpox in England and France* (Philadelphia, 1957); A. Rusnock, 'The Weight of Evidence and the Burden of Authority: Case Histories, Medical Statistics and Smallpox Inoculation', in R. Porter, ed., *Medicine in the Enlightenment* (Amsterdam, 1995), pp. 289–315; see also n. 4 above.

9 Fisher, *Edward Jenner* discusses his dealings with Parliament, as does Baron, *Life of Edward Jenner*.

10 The literature on women and gender issues in relation to science is now extensive. In addition to works cited elsewhere, see, for example, G. Lloyd, *The Man of Reason: 'Male' and 'Female' in Western Philosophy* (London, 1984); P. Phillips, *The Scientific Lady: A Social History of Women's Scientific Interests 1520–1918* (London, 1990); M. Ogilvie, *Women in Science: Antiquity through the Nineteenth Century* (Cambridge, MA, 1986); L. Hunter and S. Hutton, eds, *Women, Science and Medicine 1500–1700* (Stroud, 1997); A. Shteir, *Cultivating Women, Cultivating Science: Flora's Daughters and Botany in England 1760–1860* (Baltimore and London, 1996).

11 Phillips, *Scientific Lady*, pt 3; M. Walsh, *'Doctors Wanted, No Women Need Apply': Sexual Barriers in the Medical Profession, 1835–1975* (New Haven and London, 1977); J. Donnison, *Midwives and Medical Men: A History of Inter-professional Rivalries and Women's Rights* (London, 1977); E. Riska and K. Wegar, eds, *Gender, Work and Medicine* (London, 1993), chap. 2; S. Fletcher, *Feminists and Bureaucrats: A Study of the Development of Girls' Education in the Nineteenth Century* (Cambridge, 1980).

12 J. Morrell and A. Thackray, *Gentlemen of Science: Early Years of the British
 Association for the Advancement of Science* (Oxford, 1981); G. Basalla *et al.*,
 eds, *Victorian Science: A Self-portrait from the Presidential Addresses to the
 British Association for the Advancement of Science* (New York, 1970).

13 A. Desmond, *The Politics of Evolution: Morphology, Medicine and Reform in
 Radical London* (Chicago, 1989); S. Jacyna, 'Somatic Theories of Mind and
 the Interests of Medicine in Britain', *Medical History*, 26 (1982), pp. 233–58,
 and 'Immanence or Transcendence: Theories of Life and Organisation in
 Britain, 1790–1835', *Isis*, 74 (1983), pp. 310–29; K. Figlio, 'Theories of
 Perception and the Physiology of Mind in the Late Eighteenth Century',
 History of Science, 13 (1975) pp. 177–212.

14 A. Wilson, *The Making of Man-midwifery: Childbirth in England, 1660–1770*
 (London, 1995); Donnison, *Midwives and Medical Men*.

15 T. J. Pettigrew, *Memoirs of the Life and Writings of the Late John Coakley
 Lettsom, with a Selection from His Correspondence* (London, 1817);
 J. Abraham, *Lettsom: His Life, Times, Friends and Descendants* (London, 1933);
 T. Hunt, ed., *The Medical Society of London 1773–1973* (London, 1972);
 R. Porter, 'John Coakley Lettsom and "the Highest and Most Divine
 Profession that can Engage Human Intellect"', *Transactions of the Medical
 Society of London*, CXI (1994–5), pp. 22–34.

16 M. Abrams, *A Glossary of Literary Terms* (Fort Worth, 1993); R. Williams,
 Keywords: A Vocabulary of Culture and Society, rev. edn (London, 1983);
 A. Cunningham and N. Jardine, eds, *Romanticism and the Sciences*
 (Cambridge, 1990).

17 Cunningham and Jardine, *Romanticism and the Sciences*; P. Cantor, *Creature
 and Creator: Myth-making and English Romanticism* (Cambridge, 1984);
 E. Shaffer, ed., *The Third Culture: Literature and Science* (Berlin, 1998),
 section on Romanticism, esp. Nigel Leask's article on Shelley and Hutton.

18 D. Thomson, *Raeburn: The Art of Sir Henry Raeburn 1756–1823* (Edinburgh,
 1997); P. Scott, *Walter Scott and Scotland* (Edinburgh, 1981); D. Broun *et al.*,
 eds, *Images and Identity: The Making and Re-making of Scotland through the
 Ages* (Edinburgh, 1998); W. Ferguson, *The Identity of the Scottish Nation:
 An Historic Quest* (Edinburgh, 1998). The importance of Scottishness is a
 theme in Andrew Carnegie's biography of James Watt, first published in
 1905. At this time, Carnegie had a copy made of the 1792 portrait of Watt
 by von Breda, which is now owned by Heriot Watt University. (The von
 Breda itself is in the National Portrait Gallery, London.) The Scottish
 National Portrait Gallery owns ten portraits of Watt in a variety of media.

19 Mrs J. Herschel, *Memoirs and Correspondence of Caroline Herschel* (London,
 1876; 2nd edn, 1879); M. Kirlew, *Famous Sisters of Great Men* (London, 1936);
 H. Ashton and K. Davies, *I Had a Sister* (London, 1937); M. Tabor, *Pioneer*

Women: Fourth Series (London, 1933), pp. 5–33; C. Lubbock, *The Herschel Chronicle* (Cambridge, 1933). Further references are in M. Ogilvie, *Women in Science: Antiquity through the Nineteenth Century* (Cambridge, MA, and London, 1986).

20 D., I., J. and M. Millar, *Dictionary of Scientists* (Cambridge, 1996), pp. 152–3; A. Armitage, *William Herschel* (London, 1962); J. Sidgwick, *William Herschel: Explorer of the Heavens* (London, 1953); M. Hoskin, *William Herschel and the Construction of the Heavens* (New York, 1964); Lubbock, *Herschel Chronicle*.

21 C. Herschel, *Catalogue of Stars, taken from Mr. Flamsted's Observations* (London, 1798) (the quotation is on p. 5).

22 Herschel, *Memoirs and Correspondence*, 2nd edn (1879), p. 274.

23 *Ibid.*, p. 338.

24 E. Patterson, *Mary Somerville and the Cultivation of Science, 1815–1840* (The Hague, 1983); Martha Somerville, *Personal Recollections, from Early Life to Old Age, of Mary Somerville; with Selections from her Correspondence* (London, 1873). Further references are in Ogilvie, *Women in Science*.

25 D. Lardner, *The Steam Engine Explained and Illustrated; with an Account of its Invention and Progressive Improvement, and its Application to Navigation and Railways; including also A Memoir of James Watt*, 7th edn (London, 1840), first published as *Popular Lectures on the Steam Engine* in 1828. Lardner was a prolific author who also wrote *System of Algebraic Geometry* (London, 1823); *A Rudimentary Treatise on the Steam Engine* (London, 1848); *Animal Physics, or the Body and its Functions Familiarly Explained* (London, 1857); *Chemistry for Schools* (London, 1859). See J. Hays, 'The Rise and Fall of Dionysius Lardner', *Annals of Science*, 38 (1981), pp. 527–42.

26 On the history of the Royal Institution, see B. Jones, *The Royal Institution: its Founders and its First Professors* (London, 1871); T. Martin, *The Royal Institution* (London, 1942); M. Berman, *Social Change and Scientific Organisation: The Royal Institution 1799–1844* (London, 1978). Examples of the Christmas lectures are W. Bragg, *Old Trades and New Knowledge: Six Lectures Delivered at the Royal Institution* (London, 1933); H. Melville, *Big Molecules* (London, 1958).

27 Patterson, *Mary Somerville* discusses her portraits on pp. 77, 89–90, 107–8, 141–2. Somerville was particularly friendly with Chantrey, who was a Fellow of the Royal Society, as Patterson indicates. See also A. Potts, *Sir Francis Chantrey 1781–1841, Sculptor of the Great* (London, 1980), esp. pp. 26–7; C. Binfield, ed., *Sir Francis Chantrey: Sculptor to an Age 1781–1841* (Sheffield, 1981), pp. 62, 68. Many of Somerville's publications contained portraits as frontispieces.

28 Baron, *Life of Edward Jenner*, p. 405.

29 H. K. Higton, 'Elias Allen and the Role of Instruments in Shaping the

Mathematical Culture of Seventeenth-Century England', unpub. PhD
dissertation, University of Cambridge, 1996, esp. pp. 1–3, 77–9, 281–2. I am
extremely grateful to Dr Higton both for drawing my attention to
Hollar's portrait of Allen and for giving me access to her work. On
Rubens's portraits of Thomas Howard, Earl of Arundel, see *Corpus
Rubenianum Ludwig Burchard: An Illustrated Catalogue of the Work of Peter
Paul Rubens* (London, 1968–), vol. 19 (ed. F. Huemer, 1977), pp. 105–10, esp.
pp. 105–7. Mead is known to have owned the picture in 1743; it was sold
following his death in 1754.

30 S. Quinn, *Marie Curie: A Life* (London, 1995), esp. chaps 12–14; E. Curie,
Madame Curie (London, 1938); M. Curie, *Pierre Curie: With the
Autobiographical Fragments of Marie Curie* (1923; London, 1963); R. Reid,
Marie Curie (London, 1974); M. and G. Rayner-Canham, eds, *A Devotion to
Their Science: Pioneer Women of Radioactivity* (Philadelphia, 1997).

IV PORTRAITURE IN PRACTICE

1 *Portraits of Excellence* (Edinburgh, 1997).
2 Personal communication from Dr L. Yellowlees.
3 D. Thomson, *Raeburn: The Art of Sir Henry Raeburn 1756–1823* (Edinburgh,
 1997), esp. 'Manners, Morals and Characters: Henry Raeburn and the
 Scottish Enlightenment' by Nicholas Phillipson, pp. 29–38.
4 Colin Bell was quoted in the *Times Higher Education* article. He also wrote
 the foreword to *Portraits of Excellence*, the source of the second
 quotation. Bell's portrait appears in the volume, which is not paginated.
5 Tricia O'Malley is quoted at the beginning of *Portraits of Excellence* in a
 short piece about the photographers.
6 *Tom Phillips: The Portrait Works* (London, 1989) contains extensive com-
 mentaries. See, for example, pp. 64–6 on the statistician Sir Claus Moser.
7 *Educating Eve: Five Generations of Cambridge Women* (Cambridge, n.d.).
8 See, for example, A. Pickering, ed., *Science as Practice and Culture*
 (Chicago, 1992); C. Smith, *The Science of Energy: A Cultural History of
 Energy Physics in Victorian Britain* (London, 1998); C. Lawrence and
 S. Shapin, eds, *Science Incarnate: Historical Embodiments of Natural Knowledge*
 (Chicago, 1998). Compare W. Bynum, *Science and the Practice of Medicine
 in the Nineteenth Century* (Cambridge, 1994). Much of the recent interest in
 writing biographies of practitioners of science, medicine and technology
 lies precisely in the possibilities they offer for exploring practice.
9 For example, N. Konstan, *Sculpture: The Art and Practice* (London, 1984);
 J. Bolten, *Method and Practice: Dutch and Flemish Drawing Books, 1600–1750*
 (Landau, Pfalz, 1985).

10 M. Baxandall, *Painting and Experience in Fifteenth-century Italy: A Primer in the Social History of Pictorial Style*, rev. edn (Oxford, 1988), for example, discusses contracts.

11 On the Royal College of Physicians, see the various catalogues of their portrait collections, G. Clark, *A History of the Royal College of Physicians of London*, 2 vols (Oxford, 1964–6), and the biographies of Fellows, initially known as Munk's *Roll*. The College produces a pamphlet that foregrounds the modern building's success.

12 For example, J. Goodison, *Catalogue of Cambridge Portraits: I: The University Collection* (Cambridge, 1955); *idem, Catalogue of the Portraits in Christ's, Clare and Sidney Sussex Colleges* (Cambridge, 1985); R. Poole, *Catalogue of Portraits in the Possession of the University, Colleges, City and County of Oxford*, 3 vols (Oxford, 1912–26).

13 J. Woodall, ed., *Portraiture: Facing the Subject* (Manchester, 1997), p. 20 (editor's introduction); see also the essays in pt 4.

14 J. Simon, *The Art of the Picture Frame: Artists, Patrons and the Framing of Portraits in Britain* (London, 1996). Prints are a major example of such transformations for the period under discussion here. See, for example, E. D'Oench, *'Copper into Gold': Prints by John Raphael Smith 1751–1812* (New Haven and London, 1999); T. Clayton, *The English Print, 1688–1802* (New Haven and London, 1997); R. Godfrey, *Printmaking in Britain: A General History from Its Beginnings to the Present Day* (New York, 1978); S. Lambert, *The Image Multiplied: Five Centuries of Printed Reproductions of Paintings and Drawings* (New York, 1987).

15 Michael Faraday is a good example; see G. Prescott, 'Faraday: Image of the Man and the Collector', in D. Gooding and F. James, eds, *Faraday Rediscovered: Essays on the Life and Work of Michael Faraday, 1791–1867* (Basingstoke, 1985), pp. 14–31. I am grateful to Dr James and Dr Prescott for their help in relation to Faraday.

16 Doubts about the authenticity of the picture as a self-portrait are expressed in correspondence in the (London) National Portrait Gallery archives. I thank Michal Sofer for drawing my attention to it.

17 See *The Quick and the Dead: Artists and Anatomy* (London, 1997), pp. 17, 40 for examples of John Bell's work. On Charles Bell, see G. Gordon-Taylor and E. Walls, *Sir Charles Bell: His Life and Times* (Edinburgh and London, 1958); L. Jordanova, 'The Representation of the Human Body: Art and Medicine in the Work of Charles Bell' in B. Allen, ed., *Towards a Modern Art World* (New Haven and London, 1995), pp. 79–94.

18 R. Desmond, *Wonders of Creation: Natural History Drawings in the British Library* (London, 1986); B. Stafford, *Voyage into Substance: Art, Science, Nature and the Illustrated Travel Account 1760–1840* (Cambridge, MA, 1984);

M. Jacobs, *The Painted Voyage: Art, Travel and Explorations, 1564–1875* (London, 1995). Compare P. Booker, *A History of Engineering Drawing* (London, 1979).

19 The most accessible work on Mead and his circle that reveals their contacts with artists remains A. Smart, *Allan Ramsay: Painter, Essayist and Man of the Enlightenment* (New Haven and London, 1992).

20 C. Nichols, ed., *Dictionary of National Biography: Missing Persons* (Oxford and New York, 1993), p. 110 (under Byron); A. Winter, 'A Calculus of Suffering: Ada Lovelace and the Bodily Constraints on Women's Knowledge in Early Victorian England', in Lawrence and Shapin, *Science Incarnate*, pp. 202–39; B. Woolley, *The Bride of Science: Romance, Reason and Byron's Daughter* (London, 1999).

21 De la Beche is a lead player in M. Rudwick, *The Great Devonian Controversy: The Shaping of Scientific Knowledge among Gentlemanly Specialists* (Chicago, 1985). See also P. McCartney, *Henry de la Beche: Observations on an Observer* (Cardiff, 1977).

22 G. Brown, comp., *Lives of the Fellows of the Royal College of Physicians of London* (London, 1955), p. 55 (vol. 4 in the Munk's *Roll* series).

23 G. Ferry, *Dorothy Hodgkin: A Life* (London, 1998). It is worth noting that despite her importance as a scientist, Dorothy Hodgkin is not a household name.

24 *Ibid.*, p. 395.

25 The special status of the hand was made clear by Charles Bell in *The Hand* (London, 1833), a work of natural theology that affirmed God's design in the universe. The significance of the hand is at the heart of Schupbach's explanation of Rembrandt's painting in *The Paradox of Rembrandt's 'Anatomy of Dr. Tulp'* (London, 1982). Tulp and Bell were both surgeons.

26 See, for example, *Henry Moore: Friendship and Influence* (Norwich, 1998); W. Packer, *Henry Moore: An Illustrated Biography* (London, 1985); D. Mitchinson and J. Stallabrass, *Henry Moore* (London, 1992).

27 Smart, *Allan Ramsay*, esp. pp. 192–5 on Ramsay's affinities with Chardin; the link with Hunter in particular is made on p. 195. The point has also been made by P. Conisbee, *Chardin* (Oxford, 1986), p. 170.

SELECT BIBLIOGRAPHY

Barber, T., *Mary Beale: Portrait of a Seventeenth-Century Painter, Her Family and Her Studio* (London, 1999)

Benkard, E., *Undying Faces: A Collection of Death Masks* (London, 1929)

Binfield, C., *Sir Francis Chantrey: Sculptor to an Age 1781–1841* (Sheffield, 1981)

Blackwood, J., *London's Immortals: The Complete Outdoor Commemorative Statues* (London, 1989)

Booth, C., 'Robert Willan MD FRS (1757–1812): Dermatologist of the Millennium', *Journal of the Royal Society of Medicine*, 92 (1999), pp. 313–18

Brilliant, R., *Portraiture* (London, 1991)

Brock, C. Helen, *Dr William Hunter's Papers and Drawings in the Hunterian Collection of Glasgow University Library: A Handlist* (Cambridge, 1996)

Brown, L., *A Catalogue of British Historical Medals 1760–1960*, 3 vols (London, 1980–95)

Burgess, R., *Portraits of Doctors and Scientists in the Wellcome Institute of the History of Medicine* (London, 1973)

Bynum, W., E. J. Browne and R. Porter, eds, *Macmillan Dictionary of the History of Science* (London, 1981)

Catalogue of Portraits and Busts in the Royal College of Surgeons of England, with Short Biographical Notices (London, 1930[?])

Coen, E., *The Art of Genes: How Organisms Make Themselves* (Oxford, 1999)

Dictionary of National Biography (Oxford, 1885–)

Driver, A., *Catalogue of Engraved Portraits in the Royal College of Physicians of London* (London, 1952)

Educating Eve: Five Generations of Cambridge Women (Cambridge, n.d.)

Empson, J., 'Little Honoured in His Own Country: Statues in Recognition of Edward Jenner MD FRS', *Journal of the Royal Society of Medicine*, 89 (1996), pp. 514–18

Fortune, B. F., and D. J. Warner, *Franklin and His Friends: Portraying the Man of Science in Eighteenth-century America* (Washington, DC, 1999)

Garlick, K., *Sir Thomas Lawrence: A Complete Catalogue of the Oil Paintings* (Oxford, 1989)

Gillispie, C. C., ed., *Dictionary of Scientific Biography* (New York, 1970–80)

Hackmann, W. D., *Apples to Atoms: Portraits of Scientists from Newton to Rutherford* (London, 1986)

Hall, A. R., *The Abbey Scientists* (London, 1966)

Howsam, L., *Scientists since 1660: A Bibliography of Biographies* (Aldershot, 1997)

Jordanova, L. J., 'Medical Men 1780–1830', in J. Woodall, ed., *Portraiture: Facing the Subject* (Manchester, 1997), pp. 101–15

——, 'Science and Nationhood: Cultures of Imagined Communities', in G. Cubitt, ed., *Imagining Nations* (Manchester, 1998), pp. 192–211

Kemp, M., *Dr William Hunter at the Royal Academy of Arts* (Glasgow, 1975)

Lawrence, C., and S. Shapin, eds, *Science Incarnate: Historical Embodiments of Natural Knowledge* (Chicago, 1998)

Lefanu, W., *A Catalogue of the Portraits and Other Paintings, Drawings and Sculpture in the Royal College of Surgeons of England* (Edinburgh and London, 1960)

Mannings, D., 'Sir John Medina's Portraits of the Surgeons of Edinburgh', *Medical History*, 23 (1979), pp. 176–90

Masson, A., *Portraits, Paintings and Busts in the Royal College of Surgeons of Edinburgh* (Edinburgh, 1995)

Medals Mostly Medical (London, 1986)

Millar, D., I., J. and M., *Dictionary of Scientists* (Cambridge, 1996)

Munk, W., *The Roll of the Royal College of Physicians of London*, 5 vols (London, 1861 and 1878), continued as *Lives of the Fellows of the Royal College of Physicians of London*

Negus, V., *Artistic Possessions at the Royal College of Surgeons of England* (Edinburgh and London, 1967)

Ogilvie, M., *Women in Science, Antiquity through the Nineteenth Century: A Biographical Dictionary with Annotated Bibliography* (Cambridge, MA, 1986)

Phillips, T., *The Portrait Works* (London, 1989)

——, *Works and Texts* (London, 1992)

Pointon, M., *Hanging the Head: Portraiture and Social Formation in Eighteenth-century England* (New Haven and London, 1993)

Portraits of Excellence (Edinburgh, 1997)

Potts, A., *Sir Francis Chantrey 1781–1841: Sculptor of the Great* (London, 1980)

Robinson, N., *The Royal Society Catalogue of Portraits* (London, 1980)

Sakula, A., *Royal Society of Medicine, London: Portraits, Paintings and Sculptures* (London, 1988)

Shapin, S., '"A Scholar and a Gentleman": The Problematic Identity of the Scientific Practitioner in Early Modern England', *History of Science*, 29 (1991), pp. 279–327

Shawe-Taylor, D., *Genial Company: The Theme of Genius in Eighteenth-century British Portraiture* (Nottingham, 1987)

Sheets-Pyenson, S., 'New Directions for Scientific Biography: The Case of Sir William Dawson', *History of Science*, 28 (1990), pp. 399–410

Shortland, M., and R. Yeo, eds, *Telling Lives in Science: Essays on Scientific Biography* (Cambridge, 1996)

Sinclair, S., *With Head & Heart & Hand: Photographs of 20th Century British Doctors by Nick Sinclair* (text by Stephen Lock and Christopher Booth) (London, 1997)

Smailes, H., comp., *The Concise Catalogue of the Scottish National Portrait Gallery* (Edinburgh, 1990)

Smart, A., *Allan Ramsay: Painter, Essayist and Man of the Enlightenment* (New Haven and London, 1992)

Taylor, S., *John Hunter and His Painters* (pamphlet) (London, 1993)

Thomson, D., *Raeburn: The Art of Sir Henry Raeburn 1756–1823* (Edinburgh, 1997)

Turner, J., ed., *The Dictionary of Art*, 34 vols (London, 1996)

Walsh, E., and R. Jeffree, *'The Excellent Mrs Mary Beale'* (London, 1975)

Walters, D., *A Catalogue of Selected Portraits and Pictures at Apothecaries Hall* (London, 1997)

West, S., ed., *Guide to Art* (London, 1996)

Williams, T., ed., *A Biographical Dictionary of Scientists* (London, 1969)

Wolstenholme, G., *et al.*, *The Royal College of Physicians of London: Portraits, Catalogue II* (Amsterdam, 1977)

——, ed., *The Royal College of Physicians of London: Portraits* (London, 1964)

Woodall, J., ed., *Portraiture: Facing the Subject* (Manchester, 1997)

Yung, K. K., comp., *National Portrait Gallery: Complete Illustrated Catalogue 1856–1979* (London, 1981)

LIST OF ILLUSTRATIONS

1 Robert Walker, *John Evelyn*, 1648, oil on canvas, 87.9 × 64.1 cm. National Portrait Gallery, London. Photo: © NPG.

2 C. J. Allen and J. H. McNair, Obverse and reverse of medal showing Alfredo Antunes Kanthack, 1900, bronze, 9.5 × 6.4 cm (pointed oval). Royal College of Physicians of London.

3 William Wyon, The Royal Society of London's Royal Medal (Gold), dated 1833, d: 7 cm. British Museum, London. Photo: © The British Museum.

4 Portrait of William Cullen with a classical bust, from T. J. Pettigrew, *Medical Portrait Gallery*, 4 vols (London, 1838–40), vol. II. Photo: © The Wellcome Trust Medical Photographic Library.

5 John Jabez Mayall, *Sir John Herschel, 1st Bt*, c. 1848, daguerreotype, 8.6 × 7 cm. National Portrait Gallery, London. Photo: © NPG.

6 Partial page of Enrico Coen's passport, 1994. Photo courtesy of Dr Coen.

7 Godfrey Argent, *Sir Geoffrey Allen*, 1977, photograph. The Royal Society, London. Photo: © Godfrey Argent.

8 A. Diethe, *Sir William and Caroline Herschel*, 1814, coloured lithograph, 34.7 × 25.7 cm. Photo: © The Wellcome Trust Medical Photographic Library.

9 John Raphael Smith, *Edward Jenner*, 1800, mezzotint, 45.2 × 35 cm. © The Wellcome Trust Medical Photographic Library.

10 W. Angus after Miller, *Dr. William Hunter*, 1783, line engraving from the *European Magazine*, 15.9 × 9.6 cm. Photo: © The Wellcome Trust Medical Photographic Library.

11 Arthur Pond, *Richard Mead*, 1739, etching, 25.4 × 18.5 cm. National Portrait Gallery, London. Photo: © NPG.

12 Allan Ramsay, *Portrait of Richard Mead*, 1747, oil on canvas, 236.7 × 144 cm. Coram Foundation, London. Photo: Bridgeman Art Library.

13 William Nutter after William Hogarth, *Captain Thomas Coram*, 1796, stipple engraving, 57.4 × 41 cm. National Portrait Gallery Archives, London (Engravings Collection). Photo: © NPG.

14 Jean Simon after Sir Peter Paul Rubens, *Theodorus Turquetus*

Mayernius..., *c.* 1753/4, mezzotint, 35 × 25.5 cm. Photo: © The Wellcome Trust Medical Photographic Library.

15 Augustus Pugin and Thomas Rowlandson(?) after William Kent and Michael Rysbrack, *Sir Isaac Newton's Monument*, 1812(?), coloured aquatint. Photo: © The Wellcome Trust Medical Photographic Library.

16 Porcelain mug decorated with an image of Edward Jenner. Photo: © NPG.

17 Joseph Robinson (?), *Robert Willan*, 1808, miniature on ivory (obverse), hair and seed pearls (reverse), 7.4 × 5.7 cm. Royal College of Physicians of London. Photo: by courtesy of the National Portrait Gallery, London.

18 John Michael Rysbrack, Death mask of Sir Isaac Newton, 1726, iron cast, 19.7 × 14.6 cm. National Portrait Gallery, London. Photo: © NPG.

19 Mary Beale, *Thomas Sydenham*, 1688, oil on canvas, 76.2 × 61 cm. National Portrait Gallery, London. Photo: © NPG.

20 Harriet Moore, *Michael Faraday at the Royal Institution*, *c.* 1850–55, watercolour on paper, 41 × 47.2 cm. The Royal Institution of Great Britain. Photo: by courtesy of the National Portrait Gallery, London.

21 Gabriella Bollobas, *Paul Dirac*, 1973, copper, h: 35.6 cm. The Royal Society, London.

22 Mary and Thomas(?) Black, *Messenger Monsey*, 1764, oil on canvas, 127 × 101.5 cm. Royal College of Surgeons of England, London.

23 Ramsey & Muspratt, *Dorothy Mary Crowfoot Hodgkin*, *c.* 1937, bromide print, 37.8 × 30.1 cm. National Portrait Gallery, London. Photo: © Ramsey & Muspratt/NPG.

24 Wenceslas Hollar, Frontispiece to Thomas Sprat, *History of the Royal Society* (1667), etching. British Museum, London. Photo: © The British Museum.

25 David le Marchand, *Sir Christopher Wren*, *c.* 1723, ivory medallion, 12.7 × 9.2 cm. National Portrait Gallery, London. Photo: © NPG.

26 Prudence Cuming, *Rosa Beddington FRS*, 1999, photograph. The Royal Society, London.

27 William Faithhorne the Elder, *The true and lively Pourtraicture of Valentine Greatrakes Esq....*, 1666, line engraving, 16.4 × 13.4 cm. Photo: © The Wellcome Trust Medical Photographic Library.

28 George Vertue after R. Shmutz, Line engraving showing Ambrose Godfrey the Elder, 1718, 22.1 × 14.5 cm. National Portrait Gallery, London. Photo: © NPG.

29 Wenceslas Hollar after H. van der Borcht, *Elias Allen*, 1666, etching, 25.4 × 18.5 cm. National Portrait Gallery, London. Photo: © NPG.

30 Philippe Tassaert after Thomas King, *John Harrison...*, 1768, mezzotint.

Board of Trustees of the Science Museum, London. Photo:
© NMPFT/Science and Society Picture Library.

31 Joseph Wright, *Erasmus Darwin*, 1770, oil on canvas, 76 × 63.5 cm.
National Portrait Gallery, London. Photo: © NPG.

32 Sir Francis Chantrey, *James Watt*, 1841, funerary statue. St Mary's
Church, Handsworth, Birmingham. Photo: City of Birmingham
Museum and Art Gallery.

33 The Council Chamber of the Royal College of Surgeons of England,
Lincoln's Inn Fields, London, 1999. Photo: © RCSE.

34 A. R. Burt after Henry Wyatt, *Griffith Rowlands Esqr., Surgeon*, stipple
engraving, 24.8 × 18.3 cm. Photo: © The Wellcome Trust Medical
Photographic Library.

35 Leonard Darwin, *Charles Darwin*, 1870s(?), Woodbury print. Photo:
© The Wellcome Trust Medical Photographic Library.

36 Kilburn & Lenthall, *Florence Nightingale*, c. 1854, *carte de visite*, 8.7 × 5.4 cm.
National Portrait Gallery, London. Photo: © NPG.

37 William Wyon, Obverse of the Geological Society of London's medal
portrait of William Wollaston, c. 1831, d: 4.5 cm. © The Geological
Society of London.

38–41 Various photographers, *Cartes de visite* of Sir Roderick Impey
Murchison. Photos: National Portrait Gallery, London.

42 Bath Oliver biscuit. Photo: Michael Brandon-Jones.

43 Sir Bernard Partridge, *Sir Oliver Joseph Lodge*, 1926, black chalk,
36.2 × 25.7 cm. National Portrait Gallery, London. Photo: reproduced
by permission of Punch Ltd.

44 Roy Anderson, Cover of *Time* magazine showing Albert Einstein,
19 February 1979. © 1979 TIME Inc. Reprinted by permission. Photo:
Katz Pictures.

45 H. Channing Stephens, *Havelock Ellis*, oil on board, 17.6 × 12.5 cm.
Photo: © Royal College of Physicians of London.

46 Lock of William Hunter's hair. The Royal College of Surgeons of
England, London.

47 Tom Phillips RA, *Professor Peter Goddard*, 1996, oil on canvas, 61 × 91.4 cm.
St John's College, Cambridge. Photo: by courtesy of the Master and
Fellows of St John's College, Cambridge, © Tom Phillips.

48 Tricia Malley, Photograph of Dr Lesley J. Yellowlees, 1997. Photo
© Visual Resources, University of Edinburgh; commissioned by the
University of Edinburgh.

49 Thomas Eakins, *Professor Henry A. Rowland*, 1897, oil on canvas in a
carved chestnut-wood frame, 203.8 × 137.2 cm. Addison Gallery of
American Art, Phillips Gallery, Andover, MA (gift of Stephen C. Clark).

67 Richard James Lane after Henry Corbould, Bust of Edward Jenner, frontispiece of John Baron, *Life of Jenner* (1827), lithograph. Photo: © NPG.

68 Henry Room, *John Baron, c.* 1838, oil on canvas, 76.8 × 63.7 cm. Royal College of Physicians of London.

69 William Sharp after Sir Joshua Reynolds, *John Hunter,* 1788, engraving, 53.4 × 40.5 cm. National Portrait Gallery, London. Photo: © NPG.

70 After James Northcote, *Edward Jenner,* 1803, photogravure. Wellcome Institute, London. Photo: The Wellcome Trust Medical Photographic Library.

71 *Edward Jenner,* between 1880 and 1990, stained-glass window from a London house, 45 × 44.5 × 0.8 cm. The Wellcome Trust / Science Museum, London. Photo: © NMPFT / Science and Society Picture Library.

72 *Statue of Dr. Jenner, lately erected at Boulogne,* 30 September 1865, newspaper engraving, 28.4 × 18.9 cm. National Portrait Gallery, London. Photo: © NPG.

73 Jenner-related objects on display in the Wellcome Historical Medical Museum, London, photographed between 1913 and 1926, bromide print. Photo: © The Wellcome Trust Medical Photographic Library.

74 Professor Susan Greenfield, from the *Newsletter* of the Royal Institution, July 1998. The Royal Institution of Great Britain, London.

75 Paul Renouard, *Mme Curie,* from *L'Illustration,* 14 January 1911.

76 Spread from the 1997 catalogue *Portraits of Excellence* including Tricia Malley's portrait of Dr Lesley J. Yellowlees.

77 Spread from *Portraits of Excellence* including Tricia Malley's portrait of Clive Reeves.

78 Tom Phillips RA, Preparatory work for portrait of Professor Peter Goddard, 1996(?), oil on board, 22.7 × 17 cm. Collection of the artist. Photo: courtesy of the artist, © Tom Phillips.

79 Julia Hedgecoe, *Olga Kennard,* 4 June 1998, photograph.

80 Interior of the Royal College of Physicians of London, Regent's Park.

81 W. H. Mote after A. E. Chalon, *The Countess of Lovelace,* 1839, stipple engraving after an original of 1838, from an album owned by Michael Faraday. The Royal Institution of Great Britain, London.

82 Mary Somerville, *Self-portrait*(?), n.d., oil on board, 45.7 × 61 cm.

83 J. Stewart after J. Bell, *Arm of Charles Challoner, Marine, c.* 1826, coloured stipple engraving. Photo: © The Wellcome Trust Medical Photographic Library.

84 William Stukeley, *Richard Mead,* 1725, wash on paper, 22 × 15.2 cm. Royal College of Physicians of London.

85 Lady Byron, Sketch of Ada Lovelace on her deathbed, 1852. Bodleian Library, Oxford.

86 T. H. Maguire, *Sir Henry Thomas de la Beche*, 1851, lithograph, 28.8 × 23.9 cm. Photo: © The Wellcome Trust Medical Photographic Library.

87 Letter from Henry de la Beche to his daughter Bessie, 12 January 1837. Photo: National Museums and Galleries of Wales.

88 Letter from Henry de la Beche to Adam Sedgwick, December 1834. Cambridge University Library (MS Add.7652.1A:125f.1v). Photo: © by permission of the Syndics of Cambridge University Library.

89 Clive Riviere, *Self-portrait*, 1925, oil sketch, 25.5 × 35.8 cm (irregular). Royal College of Physicians of London.

90 Elliot & Fry, *Clive Riviere*, photograph. Photo: © The Wellcome Trust Medical Photographic Library.

91 Maggi Hambling, *Dorothy Hodgkin*, 1985, oil on canvas, 93.2 × 76 cm. National Portrait Gallery, London. Photo: © NPG.

92 Maggi Hambling, *Dorothy Hodgkin* (preparatory drawing), 1985, charcoal on paper, 76.2 × 55.8 cm. Collection of the artist. Photo: courtesy of the artist.

93 Henry Moore, *Dorothy Hodgkin's hands*, 1978, drawing, 24 × 30 cm. The Royal Society, London.

94 Anonymous bronze cast of the right hand of Harvey Cushing, 1922. Royal College of Surgeons of England, London.

95 Graham Sutherland, *Dorothy Hodgkin*, 1980, watercolour. The Royal Society, London.

96 Allan Ramsay, *William Hunter*, c. 1764, oil on canvas, 95.9 × 74.9 cm. Hunterian Art Gallery, University of Glasgow.

97 Allan Ramsay, *William Hunter*, c. 1758, black chalk heightened with white on dark blue paper, 40.5 × 30.4 cm. National Gallery of Scotland, Edinburgh. Photo: National Galleries of Scotland Picture Library.

98 Tom Phillips, Preparatory work for portrait of Professor Susan Greenfield, 1999, pen on paper, 29.3 × 21 cm. Collection of the artist. Photo: courtesy of the artist, © Tom Phillips.

INDEX